# The
# The Bauhaus and Design Theory

Edited by Ellen Lupton and J. Abbott Miller

 Thames and Hudson

## Contents

# The ABCs of ▲■●:
# The Bauhaus and Design Theory

Ellen Lupton and J. Abbott Miller

In 1923 Kandinsky proposed a universal correspondence between the three elementary shapes and the three primary colors: the dynamic triangle is inherently yellow, the static square is intrinsically red, and the serene circle is naturally blue. Today, the equation ▲■● has lost its claim to universality and works instead as a floating sign capable of assuming numerous meanings. Among them is the memory it recalls of the Bauhaus.

The Bauhaus has become the mythic origin of modernism, a site alternately revered and attacked by the generations who have grown up in its shadow. The Bauhaus is at once the restrictive father whose laws we long to overturn, and the naive child whose utopian idealism floods us with fond nostalagia. The essays collected in this monograph share an ambivalence towards modernism. Our amazement with its efforts to renovate design's formal and social potential is tempered by the sense that some fruitful directions were offered but not pursued, and that many avant-garde ideas were neutralized by the corporate culture they came to serve: the shapes and colors of ▲■● have become the material of corporate logotypes.

The Bauhaus was not a monolithic institution; like any school, it was a changing and often divisive coalition of students, faculty, and administrators, interacting with the often hostile community outside. This monograph does not try to account for the complicated history of the Bauhaus, which has been chronicled richly elsewhere; our focus is rather on the Bauhaus and *design theory*.

Thinking about design in a theoretically self-conscious way is one of the major contributions of the Bauhaus, and yet the school's focus on *vision* as an autonomous realm of expression helped engender the hostility towards verbal language which is common to post-WWII design education. We believe that a renewal of design theory could reinvigorate the community of graphic designers by encouraging critical thought about the means and ends of our work. This monograph looks at ▲■● from several vantages: Where did the fascination with these forms come from? What techniques and ideologies did they help articulate? What other theoretical models might graphic designers draw upon?

---

**1918**
World War I ends with the signing of the Treaty of Versailles. Germany is defeated; the Weimar Republic is founded.

**1919**
The Bauhaus is established in the city of Weimar. Architect Walter Gropius is the school's director.

**1920**
The Basic Course is established, with the painter Johannes Itten as its master. All incoming students take this course, which deals with the principles of design and the nature of materials. Itten's influence is seen in the expressionism which dominates Bauhaus typography.

**1923**
Under pressure from Gropius, Itten resigns. Laszlo Moholy-Nagy becomes director of the Basic Course, which is also taught by Wassily Kandinsky, Paul Klee, and Josef Albers. De Stijl and Constructivism begin to influence Bauhaus typography.

**1925**
Having lost support of the Weimar government, the Bauhaus moves to Dessau, an industrial city near Berlin. Herbert Bayer and Joost Schmidt, formerly students, join the faculty. A course in "Typography and Advertising Art" is instituted, taught by Bayer as part of the Printing Workshop.

**1928**
Gropius leaves the Bauhaus, and architect Hannes Meyer becomes director; he promotes a more dogmatic functionalism at the school. Bayer and Moholy-Nagy depart; Albers becomes head of the Basic Course, and Joost Schmidt heads the Printing Workshop.

In the opening essay, "Elementary School," J. Abbott Miller uncovers precedents for modernist design theory in the *kindergarten* movement of the nineteenth century, which, like the Bauhaus, analyzed visual experience into simple, repetitive elements such as △ , ■, and ●. Ellen Lupton's "Visual Dictionary" examines some of the formal strategies of Bauhaus design in relation to the ideal of a universal "language" of vision, an autonomous script free from the cultural limitations of alphabetic writing; this ideal was summarized by Kandinsky's sentence △ ■ ●. An essay by Mike Mills traces the historical trajectory of Herbert Bayer's 1925 geometric type design called "universal," from its avant-garde origins to its incorporation by mass culture. Julia Reinhard Lupton and Kenneth Reinhard are literary theorists, who have contributed an essay on the position of △ , ■, and ● in psychoanalysis. Physicist Alan Wolf invites us to imagine living in a space having more or less than three dimensions, and to consider the fractal structure of the natural world. Tori Egherman's essay "The Birth of Weimar" describes the tense political and economic environment in which the Bauhaus operated.

This monograph is published in conjunction with an exhibition called *The ABCs of △ ■ ●: The Bauhaus and Design Theory, from Preschool to Post-Modernism*. By "post-modernism," we refer to the culture which absorbed the lessons of the Bauhaus, emptying its forms of their avant-garde aspirations and investing them with new ones. While the visual phrase △ ■ ● once embodied the possibility of a universal script, it reappears in contemporary graphics, housewares, packaging, and fashion as a transient sign, bearing such diverse messages as "originality," "technology," "design," "the basics," "modernism," and even "post-modernism."

We believe that while many modernist design strategies remain compelling, they must be reopened to account for culture's ability to continually rewrite the meaning of visual form. The language of vision is not self-evident or self-contained, but operates in a broader field of social and linguistic values. In order for designers to take command of this broader field, we must begin to read and write about the relations between visual form and language, history, and culture.

**1930**
Architect Mies van der Rohe becomes director of the Bauhaus. Klee leaves the school in 1931; Albers and Kandinsky stay until the end.

**1932**
The Dessau Bauhaus is dissolved by the local government. Mies transfers the school to Berlin, where it operates briefly on a much smaller scale.

**1933**
The Berlin Bauhaus closes. During the 30s, numerous Bauhaus students and faculty emigrate to the U.S., including Gropius, Mies, Bayer, Moholy-Nagy, and Albers. They pursue influential careers as educators and practitioners.

**1937**
A group of Chicago industrialists found a design school, and hire Moholy-Nagy as director. Called the New Bauhaus, the school later is renamed the School of Design and then the Institute of Design. Gyorgy Kepes teaches photography and graphic design, drawing on Gestalt psychology.

**1938**
MoMA holds the exhibition *Bauhaus 1919-1928*, organized by Herbert Bayer and Walter and Ise Gropius. The show contributes to the fame of the Bauhaus in America.

**1945**
*Print* magazine publishes an article predicting the impact of the Bauhaus on the future of American design education: "To the Bauhaus, we are indebted for a new philosophy of design..."

## Elementary School

J. Abbott Miller

 nce upon a time there was a school not far from the Black Forest....
The Bauhaus has become the opening chapter to the narrative of
twentieth-century design. It is the most widely known, discussed,
published, imitated, collected, exhibited, and cathected aspect
of modern graphic, industrial, and architectural design. Its status as a founding
moment of design has been strengthened by the adoption of its methods and
ideals in schools throughout the world. The Bauhaus has taken on mythic
proportions as an originary moment of the avant-garde, a moment when a
fundamental grammar of the visual was unearthed from the debris of historicism
and traditional forms. A central element of this "grammar" was—and continues
to be—▲■●. The repetition of this trio of basic forms and primary colors in the
work of Bauhaus teachers and students evidences the school's interest in
abstraction and its focus on those aspects of the visual which could be described
as elementary, irreducible, essential, foundational, and originary.
The understanding of the Bauhaus as a point of origin is an effect of its reception
within the history of art and design, as well as a reflection of its own ideals:
Johannes Itten, who taught in the early years of the school, used unconventional
teaching methods, hoping to "unlearn" students and return them to a state of
innocence, a point of origin from which true learning could begin. This interest
in the clean slate, the first moment, is evident in Wassily Kandinsky's *Point and Line
to Plane*: "We must at the outset distinguish basic elements from other elements,
viz.–elements without which a work... cannot even come into existence."[1] From its
inception, the Bauhaus was premised on the notion of a *return* to origins in hope
of discovering a lost unity. The school's program, written by Walter Gropius
in 1919, charted the institution's mission of recovery: "Today, the arts exist in
isolation, from which they can be rescued only the conscious, co-operative
effort of all craftsmen.... The ultimate, if distant, aim of the Bauhaus is the unified
work of art...."[2] A woodcut of a Gothic cathedral graces the cover of Gropius's
manifesto, invoking the historical moment when he felt this prior unity, fullness,
and harmony had once been achieved.

1 Wassily Kandinsky,
*Point and Line to Plane*
(New York: Dover,
1979) 20.
2 Ulrich Conrads, ed.
*Programs and Manifestoes
on 20th-century
Architecture*, trans.
Michael Bullock
(Cambridge: MIT
Press, 1970) 49-53.

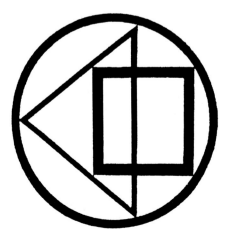

Symbol design for
Bauhaus Press, Laszlo
Moholy-Nagy, 1923.
The mark combines the
circle, square, and
triangle into an arrow-
like form. The design
was used on stationery
and advertising for
the Bauhaus Press
publications.

1 The influence of the kindergarten has been noted by several writers: Reyner Banham, *Theory and Design in the First Machine Age* (Cambridge: MIT Press, 1980); Frederick Logan, "Kindergarten and Bauhaus," *College Art Journal* Vol 10, No. 1 (Fall 1950); Marcel Franciscono, *Walter Gropius and the Creation of the Bauhaus in Weimar: The Ideals and Artistic Theories of its Founding Years* (Chicago: University of Illinois Press, 1971); Tomás Maldonado, "New Developments in Industry and the Training of the Designer," *Ulm* No. 2 (October 1958); Gillian Naylor, *The Bauhaus Reassesed* (New York: E.P. Dutton, 1985).

2 Robert B. Downs, *Friedrich Froebel* (Boston: G.K. Hall, 1978).

For Gropius, this unity would be recovered through training that would develop within students a generalized competence in crafts, forming an "indispensable basis for all artistic production." This agenda was given institutional form in the *Vorkurs*, or Basic Course, which departed from traditional academies by erasing the boundaries between craft instruction and fine art training. The Basic Course was a general introduction to composition, color, materials, and three-dimensional form that familiarized students with techniques, concepts, and formal relationships considered *fundamental* to all visual expression, whether it be sculpture, metal work, painting, or lettering. The Basic Course developed an abstract and *abstracting* visual language that would provide a theoretical and practical basis for *any* artistic endeavor. Since it was seen as the basis for all further development, the course aimed to strip away particularities in favor of discovering fundamental truths operating in the visual world. Thus ▲ ■ ● were paradigmatic of the formal laws considered to underlie all visual expression.

While the concept of a Basic Course is one of the greatest legacies of the Bauhaus, it was a notion that had many precedents in progressive educational reforms of the nineteenth-century, particularly in the *kindergarten*, as developed by its founder, Friedrich Froebel (1782-1852).[2] Froebel's greatest influence was the Swiss educator Heinrich Pestalozzi (1746-1827), whose concept of sensory education was an application of the Enlightenment ideals set forth by Jean-Jacques Rousseau (1712-1778). Rousseau's *Emile* (1762) argued that education is the cultivation of inherent faculties, rather than the imposition of knowledge. Taking this path, Pestalozzi recast the teacher as a protective figure who follows and stimulates the child's inherent intelligence. Pestalozzi sought a model of education that would build upon an evolving mastery of concepts and skills. Educational reformers often used the metaphor of the child as a "seed": education has the role of nurturing the seed to fruition. The "child garden" (*kindergarten*) was metaphorical as well as literal: early in his career as a teacher, Froebel discovered the importance of play in education, and made gardening a central part of his pedagogy. He also privileged drawing as a special mode of cognition.

Diagram of the Bauhaus Curriculum, 1923.
This diagram shows the Basic Course as the prerequisite to specialized study.
The position of *building* at the center parallels Walter Gropius's founding manifesto, which states that the "ultimate aim of all visual arts is the complete building!"

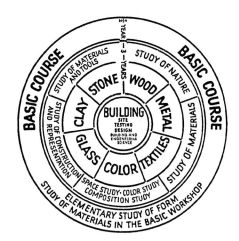

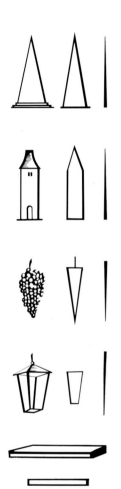

Drawing had been a central part of educational reform since the publication of Pestalozzi's widely influential *ABC's of Anschauung*,[1] written with Christoph Buss in 1803. This manual established drawing—which carried connotations of a leisurely, aristocratic pursuit—as a legitimate area of children's education. Pestalozzi, Froebel, and others in German-speaking Europe at this time championed drawing as a form of *writing* parallel to alphabetic writing. Pestalozzi's *ABC* initiated the nineteenth-century interest in "pedagogical drawing," distinguished from drawing taught in the academy tradition by the fact that it begins at an early age and is conducted through exercises taught simultaneously to a group.[2] Pestalozzi's drawing method was based on his belief that "the square was the foundation of all forms, and that the drawing method should be based upon the division of squares and curves into parts" (Ashwin 56). Through a series of synchronized, repetitive exercises, the teacher would demonstrate the figure to be drawn, name it, and then question the child about its form. After drawing the form, the child was asked to locate it within the environment. The repertoire of forms was based on a spare grammar of straight lines, diagonals, and curves. As historian Clive Ashwin notes, Pestalozzi sought to "break down the complexity of nature into its constituent forms...to identify and 'elementarise' the underlying geometry of the visual world in a way which would make it assimilable for the child" (16).

Another drawing method based on the idea of creating a reductive graphic code, an "alphabet" for drawing, was published in 1821 by Johannes Ramsauer, one of Pestalozzi's colleagues. Ramsauer's *Drawing Tutor* is premised on the idea of *Hauptformen* (main forms), that "represent the abstracted essence of physical objects" (Ashwin 43). His typology consists of three main forms: objects of rest (further divided into standing versus lying objects), objects of movement (including the directional forms of arrows, swinging objects like wheels, and turning objects such as rising smoke), and objects which combine movement and rest (including floating forms such as a boat on the water, and hanging forms such as a tree branch). Each of the "main forms" is given a linear equivalent, an abstracted sign describing an object's "essential" character.

Detail of a plate from Johannes Ramsauer's 1821 *Drawing Tutor*. Ramsauer's drawing method constructs a graphic shorthand for representing the "essence" of forms. Standing objects of rest are represented by a bottom-heavy vertical line, a hanging form would be represented with the heavy part of the line towards the top. Redrawn.

1 *Anschauung* is a German noun derived from the verb *anschauen* (to see or perceive). Clive Ashwin, *Drawing and Education in German-speaking Europe, 1800-1900* (Ann Arbor: UMI Research Press, 1981). 2 Michael Heafford, *Pestalozzi* (London: Methuen, 1967).

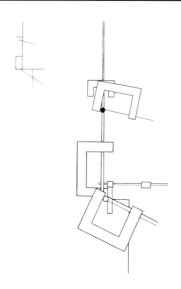

Robert Eduard Kukowka, *Analytical Drawing of the First Stage with Schema,* 1926. Produced by a student in Wassily Kandinsky's Analytical Drawing class. The drawing juxtaposes two representations of the same still-life, composed of a set of c-clamps of varying size. In the upper left, the composition is represented through a reductive symbol that conveys the essential shape of the still-life. In the larger image, outlines indicate the overlap of forms. Like Ramsauer's "main forms," Kandinsky's approach teaches analytical skills that elementarize form, arriving at a schematic sign that describes the most salient attributes of an object or scene. As in Ramsauer's *Drawing Tutor,* Kandinsky's *Point and Line to Plane* offers essentialized, linear "translations" of forms. Kandinsky, however, extends the concept to the psychological realm when he claims: "every phenomenon of the external *and of the inner world* can be given linear expression" (68).

1 Clark V. Poling, *Kandinsky's Teaching at the Bauhaus: Color Theory and Analytical Drawing* (New York: Rizzoli, 1986) 113.

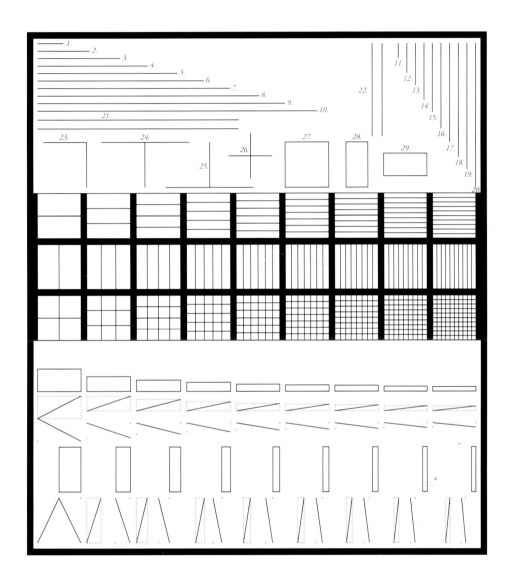

Plate from the *ABC of Anschauung*, by Heinrich Pestalozzi and Christoph Buss, 1803. Redrawn.

The *ABC* developed manual and perceptual skills through elaborate exercises in which proportion, angle, and scale were related to corresponding divisions of a square. The method was premised on breaking form down into its constituent parts. It taught drawing as a finely tuned grammar of horizontal, vertical, and diagonal lines and arcs. The encyclopedic rigor of the *ABC* results in a programmatic repetition of forms. Machine culture, rather than the *Encyclopedia*, would later fuel modernism's interest in repetition.

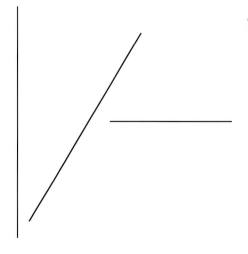

Figure from Wassily Kandinsky's *Point and Line to Plane*, originally published in 1926. Interest in early nineteenth-century pedagogical drawing methods was revived in the 1870's: many of the manuals that had become obscure were republished in the last three decades of the century. Such texts understood drawing as a normative discipline, instrumental to the socialization of children. While they aimed at realistic representation, they employed analytical strategies that would be echoed later in the work of Klee, Kandinsky, and Itten. Kandinsky, for instance, isolates the "elements" of pictorial construction (point, line, plane), identifying them as the constituent parts of a pictorial speech. Similar to the *ABC of Anschauung* (above), Kandinsky's *Point and Line to Plane* identifies a grammar of lines (right), yet he ascribes to them abstract, emotive power, rather than a strictly descriptive function.

Detail of "dot drawing" exercise from Franz Carl Hillardt, *Stygmographie, or Writing and Drawing from Points*, 1839.

The method of pedagogical drawing adopted by Froebel drew upon two earlier methods called *Stygmographie* (dot drawing) and *Netzzeichnen* (net drawing). Dot drawing consisted of a grid of dots on the student's paper correlated to a similarly gridded slate used by the teacher. Net drawing extended the points to form a continuous grid across the page. The addition of numerals to the dots or the axes of the grid allowed the teacher to dictate drawings to the classroom. Dot drawing was based on the practice of learning to write by joining dots, indicating the degree to which educators saw writing and drawing as parallel disciplines. Unlike the grids employed by sixteenth-century artists, those used in pedagogical drawing methods were for transposing *flat designs* rather than three-dimensional objects. The forms and patterns that were the subject of pedagogical drawing exercises already conformed to the flatness of the gridded field. They were viewed as disciplinary exercises—often taught with the aid of rhythmical chanting—that developed dexterity and analytical skills that would benefit the student in all areas of endeavour, not just in visual representation (Ashwin 127-132).

Hannes Beckmann, *The Different Stages of Analysis*, 1929. This is the third in a series of four drawings by a student in Kandinsky's Analytical Drawing class. The drawings generalize a still-life (ladder, table, basket, drape) into progressively more abstract forms. The drawings develop what Kandinsky described as the "structural network," which clarifies the "tensions discovered in the structure" (Poling 14). This grid-like network filters out particularities to arrive at a geometricized scheme. Nineteenth-century pedagogical drawing methods used the grid as a supplement to undeveloped perceptual and manual skills. The flat geometric designs that students transferred to gridded slates were exercises en route to naturalistic representation. Kandinsky's method works inversely: the grid enables the student to coax geometry out of natural form.

Froebel's use of the graph or "net" for drawing is an extension of his belief that the process of perception is dependent upon the concepts of horizontality and verticality. Froebel believed that there is a natural correspondence between the squared surface (*Netzfläche*) of the grid and the way we receive images on the retina (*Netzhaut*). Froebel's teaching method was to draw geometric figures on a large gridded slate at the front of the classroom, while his students replicated these shapes on gridded paper or slates. Naturalistic or "true" representation was the ultimate aim; thus the gridded exercises were a way of reducing the complexity of the visual world into simplified components. As students gained a mastery of form, the grids and geometric elements which had been used for analysis gave way to naturalism. Froebel's drawing method exemplified his program of isolating the fundamental, constructive elements of a subject and building successively on each newly acquired skill. The grid of his drawing method became the visual and theoretical paradigm for his most influential contribution to pedagogy: his "Gifts and Occupations."

Detail of a plate showing "Network Drawing" from *E. Steigers Educational Directory*, New York, 1878.

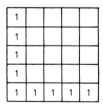

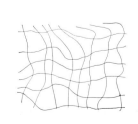

Paul Klee, Drawings from *The Thinking Eye*.
The grid appears throughout Klee's pedagogical writing as well as in his art. In the *Pedagogical Sketchbook* he describes a grid of regular intervals, like those used in nineteenth-century pedagogical drawing exercises, as having a "very primitive structural rhythm."[1] Such drawing exercises viewed the grid as a "net" in which content could be safely transferred from one place to another. As a tool for replication, the grid is conceived of as passive and transparent: its regularity is a pre-condition of its proper functioning. Klee's pedagogical writings re-consider the grid as active, rather than passive. At left, variation is introduced to the typically stable and static form of the grid. In Klee's work, grids are refigured as structural fields which actively shape representation. The ground of the image is called to the fore.

1 Paul Klee, *Pedagogical Sketchbook* (London: Faber and Faber, 1953, 1981) 22.

Between 1835 and 1850 Froebel worked on his "Gifts and Occupations"—a set of geometric blocks (Gifts) and basic craft activities (Occupations), that would become the centerpiece of his pedagogical theory. The Gifts and Occupations were introduced in a highly ordered sequence, which began in the child's second month and concluded in the last year of kindergarten at the age of six. The sequence was intended to mirror the child's physical and mental development: the malleable, brightly colored spheres from the first gift are followed by a hard, wooden sphere in the second gift, conveying a tactile, material "progression"; the second gift of the wooden sphere, cube, and cylinder encouraged an understanding of the cylinder as a combination of sphere (motion) and cube (stability). The fourth gift, a cube divided into eight smaller blocks, would teach the relationship of a whole to its parts. Gifts three through six divide the cube into smaller, increasingly complex geometries, forming a progressively finer vocabulary of elements. This vocabulary would, in Froebel's plan, become rich and various enough to enable the child to form representations of the surrounding world.

*See how many a pretty thing*
*I always from the cube can bring:*
*Chair and sofa, bench and table,*
*Desk to write at when I'm able,*
*All the household furniture,*
*Even baby's bed I'm sure;*
*Not a few such things I see;*
*Stove and sideboard here can be.*
*Many things, both old and new,*
*My dear cube brings into view;*
*So my cube much pleases me,*
*Because through it so much I see.*
*It is a little world* (Downs 16).

Walter Gropius and Fred Forbart, "Honey-Comb Bauhaus-Housing Development," 1922. Detail of an ink drawing by Farkas Molnar, depicting a plan for prefabricated, variable building components. Gropius' application of "building block" principles to the urgent task of affordable housing sought to exploit prefabrication while allowing maximum variation of form. Gropius writes: "the mass prefabrication of houses should be attempted and units should be kept in stock which would be manufactured not on the site but in permanent workshops, to be assembled later. These would include ceilings, roofs, and walls. Thus it would be like a children's box of blocks on a larger scale and on the basis of standardization and production of types" (Wingler 162). The plan was only partially realized: an experimental prototype house designed by student George Muche with Gropius' collaborator Adolf Meyer was built for the 1923 Bauhaus exhibition.

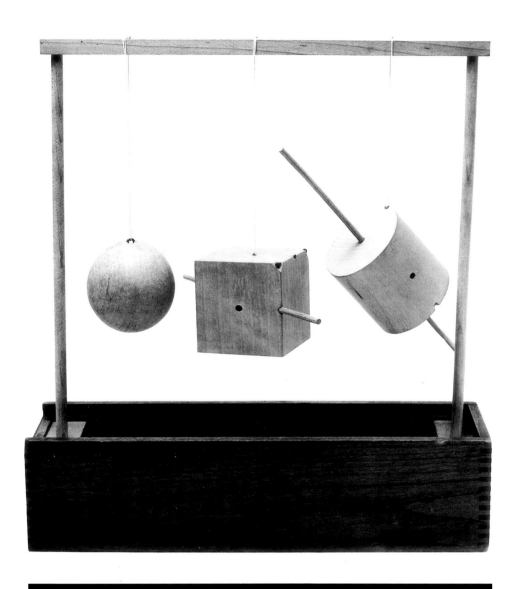

Left: Gift Number One, as represented in E. Steiger's Educational Directory of 1878.

Above: Gift Number Two, ca. 1896. 11 inches high, 10 inches long, 3 inches wide. Manufactured by the American toy company Milton Bradley.

Collection of Norman Brosterman. Photography by Joanne Savio.

"The more awkward (children's drawings) are, the more instructive an example they offer us."

Paul Klee

"Man is not finished. One must be ready to develop, open to change; and in one's life be an exalted child, a child of creation, of the Creator."
Paul Klee

"One wall (of the Bauhaus studio) was lined with... experimental studies... (using) different materials. They looked like hybrids between toys and the art of savages."[1]
Paul Klee

"To start out by 'playing' develops courage, leads in a natural manner to an inventive way of building and furthers the...facility of discovery."
Josef Albers

"learning...through ex-perimentation takes more time, entails detours and wrong directions. Walking begins with crawling, and speaking with baby talk."[2]
Josef Albers

"a modern space composition is not...the putting together of differently shaped blocks and specifically not the building of rows of blocks of the same size or of different sizes. ▶

Building materials are only a means, to be used as far as possible in expressing the artistic relations of created and divided space."[3]
Moholy-Nagy

"The purpose of my work with children is to get to the primitive urge, the original, the untouched...[evident in] the primary writing of children: drawing."
Helene Nonne-Schmidt

"Schools should view drawings by children as their visual records..and allow them to exist side by side with alphabetic writing for as long as possible."
Helene Nonne-Schmidt

"Froebel provides children with the basics: spheres, cubes, and connecting forms. Every child forms a ball when it first gets plaster in its hands, then makes a roll and continues to shape. ▶

The Bauhaus should study this...and [create] school plans from entry to university level. Why the Bauhaus? Because we look for the basic reasons of form and color...."[4]
Helene Nonne-Schmidt

1 *Paul Klee: The Thinking Eye,* ed. Jürg Spiller, trans. Ralph Manheim (London: Lund Humphries, 1961) 22, 42, 29.

2 Josef Albers, from a 1928 lecture in Prague, in Hans Wingler, *The Bauhaus* (Cambridge: MIT Press, 1969) 142.

3 Moholy-Nagy, *From Material to Architecture,* in Hans Wingler, 430.

4 Helene Nonne-Schmidt, "Kinderzeichnungen," *Bauhaus Zeitschrift für Gestaltung* Vol. 3, No. 3 (July-September, 1929): 13, 16.

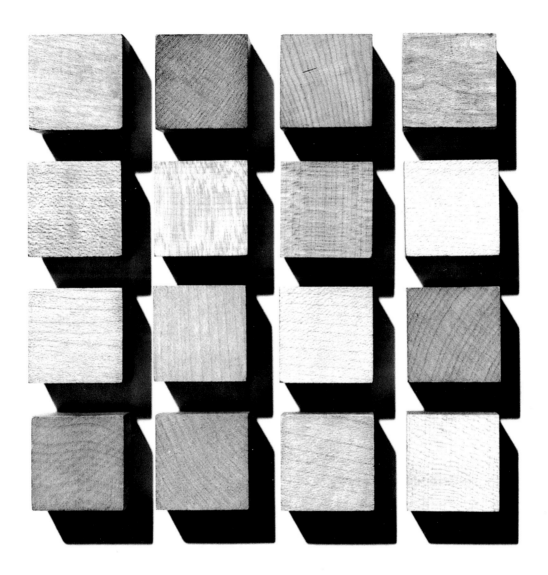

Gift Number 5, detail, shown actual size. The toy consists of a 3 x 3 inch wooden cube divided into twenty-one whole cubes, plus six half and twelve quarter cubes. The American toy manufacturer Milton Bradley, began producing Gifts and Occupations in 1896. As early as 1878, E. Steiger's Educational Directory of New York offered a range of Froebel-inspired toys. Collection of Norman Brosterman. Photography, Joanne Savio.

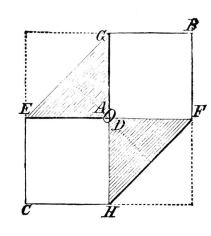

Froebel's Gifts and Occupations. Clockwise from upper left: Mat-plaiting, Card Sewing, Paper Mounting, and Paper Folding. Reproduced from *E. Steiger's Educational Directory*, 1862, New York.

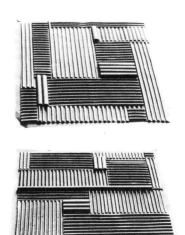

Corrugated cardboard exercise from Albers's Basic Course, 1927-28. Experimenting with the properties of different materials was a component of the Basic Course beginning with Itten's texture studies, which were charts comparing different textiles, wood, and printed patterns. Josef Albers, who later taught the materials course, described it as a form of play as well as experimentation: "Instead of pasting [paper], we will put it together by sewing, buttoning, riveting, typing, and pinning it; in other words, we fasten it in a multitude of ways. We will test the possibilities of its tensile and compression-resistant strength....
we construct with straw, corrugated cardboard, wire mesh, cellophane, stick-on labels, newspaper, wallpaper, rubber, match-boxes, confetti, phonograph needles, and razor blades.... In doing this, we do not always create 'works of art'; it is not our intention to fill museums: we are gathering 'experience'" (Wingler 142).

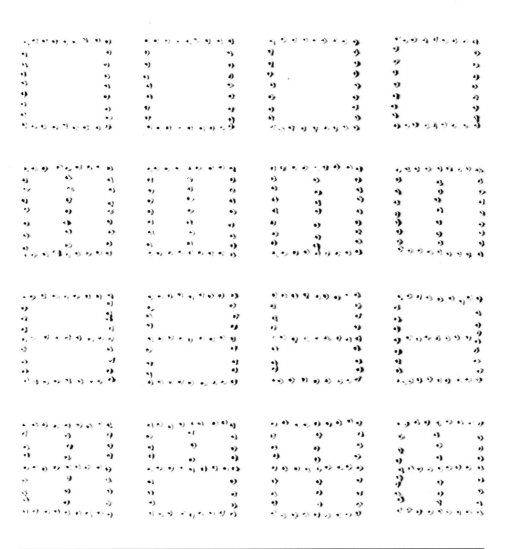

Detail of a pin-pricking exercise, from an American Froebel-inspired teacher-training album, ca. 1880. Collection of Norman Brosterman.

Froebel's Gifts and Occupations. Clockwise from upper left: Tablet-laying, Jointed Slats, Ring Laying, and Disconnected Slats. Reproduced from *E. Steiger's Educational Directory*, 1862, New York.

Detail of a construction using wooden sticks and razors, 1928, produced by a student in Josef Albers's course on materials. *Construction*, in its architectural sense, underlies the approach to much of the sculptural and pictorial composition at the Bauhaus. Both Klee and Kandinsky isolate formal "elements" that are historically prior to and underlie all visual expression. Their theoretical writings are concerned with the laws that govern the distribution and interaction of these elements. In Klee's work, the sense of composition as the arrangement of "elements" is evident in the use of discrete, often repetitive, shapes which emphasize "the autonomous existence of the pictorial elements as separate forms."[1] This additive and constructive approach relates to elementary forms of picture-making, such as basic craft activities, that fall outside of the high tradition of the fine arts.

1 Beeke Sell Tower, *Klee and Kandinsky in Munich and at the Bauhaus* (Ann Arbor: UMI Research Press, 1981) 142.

Detail of elements from *The Cork Model Maker. A Scientific Toy for Constructing Architectural, Mathematical, and Mechanical Models.* ca. 1860. The boxed set measures 9.5" x 6.5." Collection of Norman Brosterman.

*The Cork Model Maker* is a British variation on Froebel's "peas work" activity, which used soaked peas to connect wires. The label credits Thomas Edward Keen as the inventor.

Monument to Friedrich Froebel.
Representing an 1882 monument to Froebel in Schweina, Germany, this was a calling card or bookmarker for the Milton Bradley Company, which began producing Froebel toys in 1896. Bradley adapted Froebel's game of building with sticks and soaked peas into the *Tinkertoy*.

The notoriety of Froebel's Gifts and Occupations was due, in part, to the fact that the Prussian government banned the kindergarten in 1851 for its supposed atheist and socialist intentions, inadvertently giving Froebelian pedagogy an added cachet. The government denied that it had confused Friedrich Froebel (whose writings and theories are deeply pantheistic) with his nephew Karl (an outspoken atheist and socialist). The defense of the kindergarten became a favorite issue among liberals: as an early supporter remarked, "the cause of the new education [is] more or less associated in the public mind with radicalism..." (Downs 83).

The ban was part of a severe wave of reaction following the Revolution of 1848. Prussia's *Regulative* of 1854 brought teacher-training and elementary school curricula under absolute state control: the once-active tradition of pedagogical drawing fell into obscurity. The stable if repressive period that followed saw the financial, industrial, and military ascendence of Germany, culminating in the declaration of the Reich in 1871. In the interest of forging a new national and cultural identity, the Reich loosened controls on the educational system, liberalizing state schools and teaching colleges. It was in this climate that the ban on the kindergarten was lifted.

The kindergarten quickly spread throughout Europe, America, and Japan. The popularity of the Gifts and Occupations created a substantial consumer market, becoming a pervasive "visual language" of elementary forms and basic colors.[1] Members of the early avant-garde were educated in the period of the kindergarten's greatest influence: it is known that Frank Lloyd Wright, Kandinsky, and Le Corbusier were educated according to Froebel methods, and the program of the Bauhaus attests to its impact.

The liberalization of education resuscitated the tradition of pedagogical drawing, bringing older methods back into circulation (Ashwin 138). However, factions arose between educators favoring the copy techniques of pattern books and those who privileged creativity and self-expression. Georg Hirth's 1887 *Ideas about the Teaching of Drawing* attacked traditional methods and signalled the beginning of an influential Reform Movement in art education (Ashwin 19).

1 As early as 1872 the Kindergarten was part of Austria's national educational system. By 1909 there were 35 Kindergartens in Berlin, 11 in Breslau, 32 in Wurtemburg, 9 in Cologne, 19 in Dresden, 27 in Düsseldorf, 30 in Frankfurt-on-Main, 13 in Leipzig, 23 in Munich, 65 in Zurich, 73 in Basle, 72 in Vienna, 11 in Graz, 50 in Copenhagen, 191 in Holland, 30 in Finland, 10 in Paris, 4 in Rome, 254 in Japan, and 2 in Russia. By 1904, there were 2,997 Kindergartens in the U.S., where they were developed under public auspices. M.G. May, "The Provision Made in Germany and Switzerland for the Care of Children Under the Compulsory School Age" and "Appendix," *Special Reports on Educational Subjects* Vol. 22 (1909): 137-251.

Froebel School, Providence, Rhode Island, ca. 1890. Froebel's Gifts and Occupations are arranged on the tables. The façade of the school prominently featured Froebel's name and the word *Kindergarten*. Photograph courtesy of Norman Brosterman.

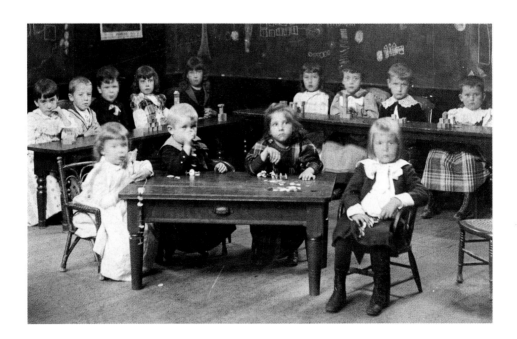

1 Children's drawings were consistently compared to the visual production of ancient, non-industrialized, and non-Western cultures. The notion of the child-as-artist coincided with the publication, in Europe, of a number of books by anthropologists and archeologists that recorded the visual culture of Egyptians, Indians of North Western Brazil, and South African Bushmen. Stuart MacDonald, *The History and Philosophy of Art Education* (London. University of London Press, 1970) 329, 330.
2 For contemporary critics on Germany's "lack of taste" see Ashwin, 145.
3 Carl Schorske, *Fin-de-siècle Vienna* (New York: Random House, 1981) 328.

An influential trend within the Reform Movement was the concept of the child-as-artist. An exhibition—the first of its kind—called *The Child as Artist* was staged at the Hamburg Museum in 1898. The show consisted of the drawings and paintings of local school children, drawings by Indian children, and a collection of Eskimo art.[1] The gradual liberalization of drawing instruction and the cultivation of the child-as-artist were linked to one another, but more importantly, they were linked to the desires of educators and intellectuals who saw the formation of an artistic culture as instrumental in renovating the country's social and economic future. The Reform Movement and the invention of the child-as-artist were largely motivated by interests in fostering a national cultural-artistic identity. This cultural renewal had the specific aim of renovating Germany's reputation, in the art industries, for ostentation and overdecoration. This cultural mission was accomplished, in part, by positing an artistic potential within every child, and by assigning the previously insignificant products of childhood with a cultural function.[2]

The visual production of children and the objects produced by adults in non-industrialized, non-Western cultures entered the new century on equal footing. Both were considered records of an originary, primary experience of vision. Artists turned to the child and the "primitive" as sources of truthful and unmediated expression: as windows onto the "childhood of art." Comparisons between children's drawings and the work of adult "primitives" were made by artists and anthropologists under the banner of "recapitulation theory"—the notion that the art of the child "recapitulates atavistically the childhood of peoples and the childhood of art."[3] This phenomenon appears in the work of Gustav Klimt, Oskar Kokoschka, and other members of the Vienna Secession, which, as Carl Schorske has remarked, projected "the ideology of aesthetic liberation back to childhood" (327). An entire room of the Secession's influential 1908 *Kunstschau* exhibition was devoted to drawings and paintings by children, an inclusion which affirmed the anti-academic stance of the Secession and bolstered its claim to an artistic rebirth.

Children's drawing represented in the catalogue to the 1898 exhibition *The Child as Artist*, held in the Kunsthalle of Hamburg.

Paul Klee, *Children's Playground*, 1937. As reproduced in *The Thinking Eye*.

The romanticism of the child-as-artist phenomenon emerges strikingly against the backdrop of worsening social conditions: children constituted a major portion of the thousands of homeless people in the early years of the Weimar Republic. The school system encouraged working-class and lower-class children to enter the labor force at the age of twelve. Middle-class students, on the other hand, attended schools that enabled their continuation on to university level. The disillusionment of many children led to their active participation in the November Revolution of 1918, and the subsequent formation of politicized youth movements. See Jack Zipes, *Fairy Tales and Fables from Weimar Days* (Hanover: University Press of New England, 1989).

Before coming to teach the Basic Course at the Bauhaus, Johannes Itten had set up his own art school in Vienna in 1916. Itten's teaching methods emerged from artistic circles in which the romantic concepts of the "child-as-artist" and the "childhood of art" were already well-established.[1] His adaptation of child-based techniques to the training of professional art students was also informed by his earlier training as a primary school teacher. Itten sought to liberate the students' creativity through a return to childhood, by introducing elementary explorations of forms and materials, automatism, blind drawing, rhythmic drawing motions, and an intuitive and mystical approach.[2] While this return to origins and primitive impulses was Itten's formidable contribution to the Bauhaus, it was also the reason for his departure. As early as mid-December 1919 public meetings were held in which angry citizens, academy professors, and artists registered complaints against the school.[3] The effect of this criticism on attitudes toward "expressionist" influences reveals itself in the development of elementary, geometric form at the Bauhaus.

The work of Itten's students, with its lopsided circles, painterly squares, and sketchy triangles, reveals that the initial interest in elementary form at the Bauhaus was in the spirit of a primary exploration. The transformation of geometric form into the precise silhouettes of machine culture was a later development at the school, which is often attributed to an increased awareness of the artist's social role. The shift towards a more sober, hard-edged geometry has been described as a progressive "rationalization" of Bauhaus pedagogy. One might also view this rationalization of form, however, as an attempt to rid elementarism of its associations with "expressionism," especially since conservative opponents of the school regularly equated expressionism with communism, bohemianism, and "foreign" influences (Miller-Lane 74). The move towards a more rational, industrial vocabulary of form countered criticism that the school had ignored its mandate to unite art and industry. Throughout the later 1920's the school's use of abstract geometric form was linked increasingly to the issue of machine production, and distanced from the expressionistic conception of a "childhood of art."

1 The use of elementary and anti-academic instruction for art students had precedents in the teaching of Hermann Obrist, who taught in Munich at the end of the century; Adolf Hölzel, who taught at the University of Stuttgart; and Franz Cizek, who taught at the *Kunstgewerbeschule* in Vienna when Itten formed his own school there.
3 Itten's teaching was influenced by the contemporary notion of "empathy," which understood gesture and movement in pictorial form as expressive of emotion (Franciscono 189).
4 Barbara Miller-Lane, *Architecture and Politics in Germany 1918-1945* (Cambridge: Harvard University Press, 1985) 71.

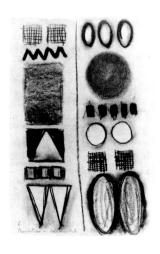

Exercise in Proportion and Value, ca. 1920, by Max Pfeiffer-Watenpfuhl, from Johannes Itten's Basic Course. Charcoal on paper, 37.3 x 24.8 cm. Courtesy of the Busch-Reisinger Museum, Harvard University.

1 Jean Laplanche and J.-B. Pontalis, *The Language of Psycho-analysis*, trans. Donald Nicholson-Smith (New York: W.W. Norton, 1973) 332.

Itten, Klee, and Kandinsky aimed at uncovering the origins of "visual language"; they sought this origin in basic geometries, pure colors, and abstraction. Their practice and pedagogy have the character of both science and fantasy. On the one hand, they constitute an analysis of forms, colors, and materials directed towards a *Kunstwissenschaft* (science of art); on the other hand they are theoretical con-structions about primordial laws of visual form that supposedly operate outside of history and culture. These speculative responses to problems of origin are parallel to fantasies of origin excavated by psychoanalysis: the origin of sexuality in *seduction*, the origin of sexual difference in *castration*, and the origin of the subject in the *primal scene*. Freud's work on these primal fantasies was elaborated through an investigation of the imaginary scenarios in the psychic life of his patients, as well as through the sexual theories offered by children: "Like collective myths, [primal phantasies] claim to provide a representation of and a 'solution' to whatever constitutes a major enigma for the child."[1]

For Klee, Kandinsky, and Itten, ▲ ■ and ● served as a script through which the *prehistory of the visible* could be analyzed, theorized, and represented. Despite its diversity, the production of the Bauhaus is united by an awareness of its departure from history, of its ambition towards a point of origin. With the assimilation of its forms and methods into modern design training, the Bauhaus itself became a point of origin. While Kandinsky, Klee, and Itten articulated a visual language through the concept of a childhood of art, the Bauhaus has become the childhood of design. Geometric form, gridded space, and a rationalist use of typography have been foregrounded as the prime lessons of the Bauhaus legacy. The linguistic potential of Bauhaus theory–evident in frequent analogies between writing and drawing–was ignored: the project of a "visual language" was taken up in isolation from, rather than in tandem with, verbal language. ▲ ■ ● became a static formal vocabulary rather than provocative first steps. Graphic design's synthesis of words and images makes it an important site for re-opening early modernism's attempt to make form discursive: to re-open it to the social and cultural dimension of visual language.

"One learns to look behind the façade, to grasp the root of things. One learns to recognize the hidden currents, the **prehistory of the visible** One learns to dig below the surface, to uncover, to find causes, to analyze."
Paul Klee, "Exact Experiments in the Realm of Art" (Wingler 148).

Detail of illustrations from *The Graphic Design Cookbook: Mix and Match Recipes for Faster, Better Layouts*, by Leonard Koren and R. Wippo Meckler. (San Francisco: Chronicle Books, 1989).
The *Cookbook* is exemplary of graphic design texts produced in the post-WWII period that have taken up the idea of graphic design as the manipulation of a fixed vocabulary of graphic "elements." According to its authors, the *Cookbook* "offers a stimulating and economical route through hundreds of archetypal graphic design devices, thinking styles, and spatial solutions." The straightforwardly pragmatic attitude of the *Cookbook* distinguishes it from similar, more theoretically-tinged design texts such as Donis Dondis's *A Primer of Visual Literacy*, and Wucius Wong's *Principles of Two-Dimensional Design*.

# Visual Dictionary

Ellen Lupton

**1** The Bauhaus was a place where diverse strands of the avant-garde came together and addressed the production of typography, advertising, products, painting, and architecture. The school's activities were widely publicized in the U.S. in the late 30s, after many of its members had emigrated to this country. The Bauhaus became equated with advanced thinking in design. Part of the Bauhaus legacy is the attempt to identify a *language of vision*, a code of abstract forms addressed to immediate, biological perception rather than to the culturally conditioned intellect. Bauhaus theorists described this language as a system analogous to—but fundamentally isolated from—verbal language. Visual form was seen as a universal and transhistorical script, speaking directly to the mechanics of the eye and brain.

**3** Paul Klee's *Pedagogical Sketchbook* (1925) and Wassily Kandinsky's *Point and Line to Plane* (1926), both published by the Bauhaus, are primers for the grammar of visual writing. Gyorgy Kepes's *Language of Vision* (1944) and Laszlo Moholy-Nagy's *Vision in Motion* (1947) use Gestalt psychology to lend the "language of vision" a scientific rationale; both books were written at the School of Design in Chicago, founded as the "New Bauhaus" in 1937.[1] Gestalt psychology has since become a dominant theoretical source for basic design teaching. Numerous textbooks have appeared since World War II which describe the "language" of design as a "vocabulary" of elements (point, line, plane, color, texture) arranged according to a "grammar" of formal contrasts (dark/light, static/dynamic, positive/negative).

**In 1923 Kandinsky claimed that there is a universal correspondence between the three basic shapes and the three primary colors.**

**2** The word "graphic" refers to both *writing* and *drawing*, two different media which employ similar tools. The word "graphic" also refers to a convention employed by the sciences— the *graph*, which represents a list of numbers as a continuous line drawn in a gridded space: the pattern formed by a graph is perceived as a *Gestalt*, a single shape or image. In the textbooks of Kandinsky, Klee, Moholy-Nagy and others, information graphics function as models for a new aesthetic, an art that is at once didactic and poetic. Scientific grids, graphs, and diagrams constituted a privileged branch of the sign; they were seen as the basis of a visual script that is anti-illusionistic yet universally comprehensible, a graphic language that avoids the conventions of perspectival realism yet is linked objectively to material fact.

**4** These texts reflect the concept of a "Basic" or Foundation course, now a common feature of art and design training in America and Europe. A Foundation program teaches students fundamental principles of design, a general language of form and materials which underlies the particular speech of the specialized professions. The first teacher of the Basic Course at the Bauhaus was Johannes Itten, whose mysticism and conspicuous eccentricity were at odds with Walter Gropius's practical plans for the school. After Itten's resignation in 1923, Kandinksy taught classes on color and the "Basic Elements of Form"; Klee taught sections of the basic form class after 1924. Beginning in 1923 Josef Albers led the materials component, while Moholy-Nagy took command of the course as a whole.[3]

This project began as a paper for a course taught by Rosemarie Bletter at the Graduate Center, City University of New York. My thinking about visual form as a systematically structured "language" is indebted to the work of Rosalind Krauss.

1  Paul Klee, *Pedagogical Sketchbook* (London: Faber and Faber, 1953, 1981); Wassily Kandinsky, *Point and Line to Plane* (New York: Dover, 1979); Gyorgy Kepes, *Language of Vision* (Chicago: Paul Theobold, 1944, 1967) and Laszlo Moholy-Nagy, *Vision in Motion* (Chicago: Paul Theobold, 1947, 1969).

2  On the Basic Course at the Bauhaus, see Marcel Franciscono, *Walter Gropius and the Creation of the Bauhaus in Weimar* (Urbana: University of Illinois Press, 1971).

**5** A key difference between verbal language and the modernist ideal of a visual "language" is the *arbitrariness* of the verbal sign, which has no natural, inherent relationship to the concept it represents. The *sound* of the word "horse," for example, does not innately resemble the *concept* of a horse. Ferdinand de Saussure called this arbitrariness the fundamental feature of the verbal sign. The meaning of a sign is generated by its relationship to other signs in the language: the sign's legibility lies in its *difference* from other signs. Saussure proposed the study of a new branch of linguistics: *semiology*, a general theory of signs, encompassing non-verbal as well as verbal systems. Saussure predicted that many customs with an apparently natural, inherent significance—for example, "polite" gestures or classical cuisine—are, at bottom, arbitrary.[1]

**6** In contrast to semiology's project to uncover the cultural function of signs, the theorists of modern design have searched for a system of form which is *natural* and universal, insured by biologically stable faculties of perception. For example, in his 1966 text *Graphic Design Manual*, Armin Hofmann writes: *"The picture... contains an inherent message. Although it costs us an effort... to 'read' its outward forms... it nevertheless speaks to us directly. Unlike lettering, the picture radiates movements, tone values and forms as forces which evoke an immediate response".*[2] For Hofmann, pictures have a universal significance, because their underlying abstract "forces" appeal to the "immediate" and natural faculty of perception rather than to cultural convention; the response they evoke is sensual and emotional rather than intellectual.

**7** In *Point and Line to Plane*, Kandinsky describes a "dictionary" that would translate numerous modes of expression into a single graphic script: *"The progress won through systematic work will create a dictionary which, in its further development, will lead to a 'grammar' and, finally, to a theory of composition that will pass beyond the boundaries of the individual art expressions and become applicable to 'Art' as a whole"* (83). My essay is a response to Kandinsky's call for a visual "dictionary." The terms compiled in this dictionary are techniques or strategies for organizing textual and pictorial material: *graph, grid, translation,* and *figure.* Such strategies were set forth as the basis of a visual script whose signs would be abstract in their form and universal in their content, a graphic code appealing directly to perception.

**...ot to cold, light to dark, and active to passive, the series is an elementary sentence in the "language" of vision.**

**8** My lexicon aims to reveal the interconnectedness of visual and verbal "writing"—not their separateness. Modern art education often discourages graphic designers from actively engaging in the writing process: instead, students commonly are taught to serve as "solvers" of pre-ordained "problems," whose function has been established in advance. Instead, the graphic designer could be conceived of as a language-worker equipped to actively initiate projects—either by literally authoring texts or by elaborating, directing, or disrupting their meaning. The graphic designer "writes" verbal/visual documents by arranging, sizing, framing, and editing images and texts. The visual strategies of design are not universal absolutes; they generate, exploit, and reflect cultural conventions.[3]

1  Ferdinand de Saussure, *Course in General Linguistics* (New York: McGraw Hill Book Company, 1956).

2  Armin Hofmann, *Graphic Design Manual: Principles and Practice* (New York: Reinhold, 1966). Similar texts include Donis Dondis, *A Primer of Visual Literacy* (Cambridge: MIT Press, 1973).

3  Jacques Derrida presents an expanded definition of writing in *Of Grammatology* (Baltimore: Johns Hopkins University Press, 1976).

# graph

A **graph** plots data in a gridded space, whose axes represent variables such as time, temperature, or quantity. Many **graphs** depict change over time with a linear mark, as in a sine curve or a "fever" chart. The **graph** belongs to the category of signs called the **index**, which has a causal relationship to its referent. For example, a photograph, a footprint, or a shadow is an index, because it results from physical contact with an object. An arrow is an index, because its meaning in any given instance depends on its proximity to an object. Indexical signs appear throughout the textbooks of Klee, Kandinsky, and Moholy-Nagy; they serve as potential characters in a universal script that would have a direct link to the physical or spiritual world.

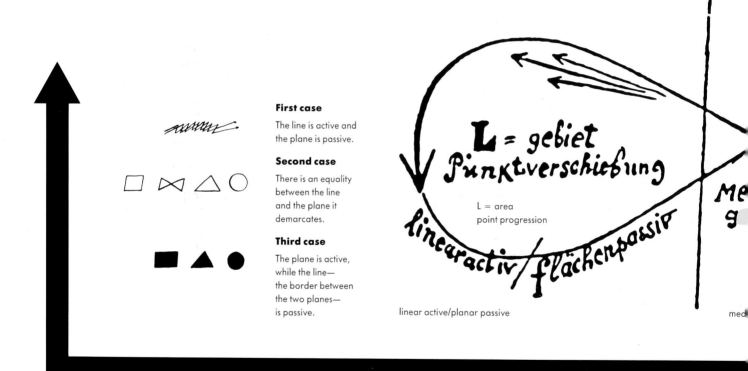

**First case**

The line is active and the plane is passive.

**Second case**

There is an equality between the line and the plane it demarcates.

**Third case**

The plane is active, while the line— the border between the two planes— is passive.

L = area
point progression

linear active/planar passive

me
g

med

**Figure 5**

For Moholy-Nagy, the essence of photography is not the camera but the chemical sensitivity of film and paper: he defined the *photogram*, or the cameraless photograph, as a "diagrammatic record of the motion of light translated into black and white and gray values" (189-90).

**Figure 4**

Moholy-Nagy extended the model of the graph to numerous natural, technological, and artistic "diagrams": sky-writing, fireworks, tire tracks, industrial time and motion studies, and peeling paint. Photograph by Harvey Croze, 1944, from *Vision in Motion*.

In the basic design textbooks of Klee and Kandinsky, the **graph** is a model of pictorial expression. Whereas the geometry of Euclid defines a **line** as an infinite accumulation of static **points**, the design primers of Klee and Kandinsky describe the line as a single point dragged across a page: the line is a trace of the artist's motion, a spatial index or **graph** of a temporal event. Similarly, a **plane** is the record left by a moving line. The diagram below, from Klee's *Pedagogical Sketchbook*, maps this temporal narrative; Klee employs a a linguistic metaphor, comparing phases in the life of a point to the *"active and passive voice"* in speech. The language of vision is written with indexical signs..

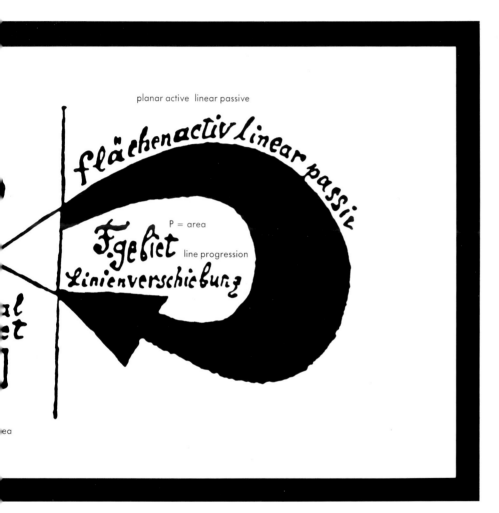

planar active  linear passive

P = area
line progression

**Figure 1**

Kandinsky reproduces this graph in *Point and Line to Plane* to show the ability of a continuous line to replace a list of numbers. Kandinsky defines the line as "the track made by the moving point; that is, its product. It is created by movement—specifically through the destruction of the intense, self-contained repose of the point" (57).

**Figure 3**

Like Kandinsky and Klee, Moholy-Nagy saw drawing as a graphic record of motion: "Every drawing can be understood as a motion study since it is a path of motion recorded by graphic means" (*Vision in Motion* 36).

**Figure 2**

In a dance choreographed by Oscar Schlemmer in 1927, the performer wears a black garment and long white poles; the body of the dancer disappears, replaced by white lines which graphically record its motion, "vivifying space in a framelike, linear fashion" (Wingler 118).

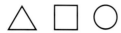

**Figure 1**
Visual signs

**Figure 2**
Kandinsky's ideal correspondence
between colors and shapes

**Figure 3**
Analytical drawing exercise,
Hanns Beckmann, 1929

**1** The term **translation** appears in Kandinsky's Bauhaus textbook *Point and Line to Plane*, where it refers to the act of drawing correspondences between graphic, linear marks and a range of non-graphic experiences, such as color, music, spiritual intuition, and visual perception: *"every phenomenon of the external and of the inner world can be given a linear expression— a kind of* **translation**" (68). Kandinsky hoped that one day all modes of expression would be **translated** through this visual script, their elements charted on one vast *"synthetic table"* or *"elementary dictionary."* ▲■● is a central example of **translation**. The series ▲■● represents Kandinsky's attempt to prove a universal correlation between color and geometry; it has become one of the most famous icons of the Bauhaus. Kandinsky conceived of these colors and shapes as a series of oppositions: yellow and blue represent the extremes of hot/cold, light/dark, and active/passive, while red is the intermediary between them. The triangle, square, and circle are graphic equivalents of the same polarities. While few designers today would accept the universal validity of the equation ▲■●, the model of visual "language" as a grammar of perceptual oppositions remains the basis of numerous textbooks of basic design.

**2** Kandinsky's series ▲■● sets forth geometry as a *script* whose meaning or "content" is the primary colors, each shape serving as a graphic container surrounding a field of hue. In 1923 Kandinsky circulated a questionnaire at the Bauhaus, which asked each participant to match intuitively △, □, and ○ with the three primary colors. Labelled *"psychological test,"* the survey attempted to validate scientifically the equation ▲■●. An elementary sentence written in the language of vision, ▲■● inspired numerous objects and projects at the Bauhaus around the time of Kandinsky's questionnaire; it came to symbolize the possibility of a visual "language'" that would communicate directly to the mechanics of the eye and brain, operating independently of cultural and linguistic conventions.

**3** The term **translation** also appears in reference to one of Kandinsky's drawing exercises, in which students represent a still-life arrangement with a linear diagram: the image is *"completely* **translated** *into energy tensions... the over-all scheme made visible by dashed lines"* (Wingler 146). Kandinsky conceived of pictorial composition as a system of "forces"; any mark or color has a relation to such geometric or psychological oppositions as vertical/ horizontal, straight/curved, warm/cold, and active/passive. Through **translation** Kandinsky aimed to express this pattern of forces with a graphic code—the series ▲■● thus embodies the theory of visual "language" as a system of perceptual oppositions. A drawing problem similar to Kandinsky's linear object studies is assigned in many basic design courses today, in which students represent an object in pure black and white values. Often called **graphic translations**, these drawings combine the apparent objectivity of a photograph with the clarity of a letterform.

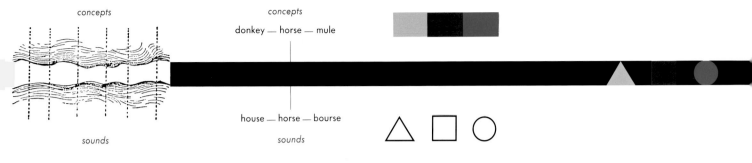

**Figure 4**
Saussure: language takes shape
between two shapeless masses

**Figure 5**
The grid of verbal language:
vertical and horizontal relationships

**Figure 6**
The grid of visual language:
vertical and horizontal relationships

**Figure 7**
Visual signs

**4** The term **translation** is also used in geometry, where it refers to the uniform movement of a figure in a single direction. In discussions of language, **translation** refers to the act of exchanging symbols from one system with symbols from another. What correspondences—and differences—might one draw between Kandinsky's "language" of vision and verbal language? How might one **translate** the visual sign ▲■● into the realm of the linguistic? According to the theory of the verbal sign proposed by the linguist Ferdinand de Saussure at the turn of the twentieth century, language consists of two distinct yet inseparable planes: sounds and concepts, or *signifiers* and *signifieds*. In order for the chaotic, undifferentiated mass of potential sounds to become the phonic material of language, it must be articulated into distinct, repeatable units; likewise, the plane of thought must be broken down into distinct concepts before it can be linked to material sounds. The realm of "thought" does not consist of ready-made, autonomous ideas existing independently of ready-made sounds—both planes are in themselves formless before they are cut up in relation to each other by the grid of language.

**5** Saussure diagrams the **grid** of language as a series of **vertical** and **horizontal** relations. The relationship between sound and concept, or signifier and signified, is vertical: the sound "horse" is linked to the concept of a horse. Horizontally, each sign is linked to all the other signs against which it is defined: the word "horse" is opposed phonically to *house*, *hose*, and *bourse*; it is opposed conceptually to "donkey," "cow," and "mule." The link between signifier and signified is not an inherent quality of the sign, but is rather a function of the overall system. A sign is thus not an autonomous, self-contained vessel of meaning, but only has *value* in relation to other signs. Kandinsky's ▲■● is analogous in some ways to a system of linguistic signs. The series represents *vertical* links between the planes of form and color; *horizontally*, each plane is structured by the oppositions hot/cold, light/dark, and active/passive. Similarly, Kandinksy's **translation** drawing exercise is an attempt to find a graphic equivalent for a pattern of perceptual, geometrical, and spiritual oppositions, a linear network which interprets the objects of experience.

**6** The central difference between the verbal sign and the ideal of the visual sign symbolized by ▲■● is the **arbitrariness** of the link between form and concept, signifier and signified, in the verbal sign. Saussure argued that language is fundamentally *social*, depending for its survival on a shared cultural agreement; in contrast, the series ▲■● symbolized the search for a language based in *natural* laws of perception. Yet the series ▲■● itself bears cultural associations. Its kinship to children's toys carries the promise of generation, while its geometry and spectral purity allies the truth of intuition with that of science. When the forms and colors of ▲■● appear in design today, they function as transient *signs*, carrying such diverse meanings as "art," "the basics," and "modernism"; they are bound to cultural meaning by the act of quotation.

A **grid** organizes space according to an *x* and *y* axis.

The **grid**, a structural form pervading Bauhaus art and design,
articulates space according to a pattern of oppositions:
vertical and horizontal, top and bottom, orthogonal and diagonal, and left and right.

Another opposition engaged by the **grid** is the opposition of **continuity** and **discontinuity**.

On the one hand, the axes of the **grid** suggest the infinite, continuous extension
of a plane in four directions; at the same time, the **grid** marks off that plane into distinct sections.

The **grid** is the underlying structure of the **chart** or **graph**,
which organizes data according to an *x* and *y* axis.
The data in a chart can be plotted as a continuous line, or it can be dispersed

across the **grid** in columns and rows of discrete figures.

Figure 1 is an exercise from Johannes Itten's Basic Course,
in which students were asked to assemble patches

of materials in a loose **grid**; many of the materials themselves are structured as
**grids**, such as cloth, wire mesh, and basketry; each fragment

invokes the extended field of fabric from which it was cut.

Kandinsky called a four-square **grid** *"the prototype of linear expression;"*
it is an elementary diagram of two-dimensional space. [Figure 2]
Similarly, the Dutch de Stijl movement, headed by Theo van Doesburg,
identified the **grid** as the fundamental origin of art. The de Stijl **grid** suggests
both the infinite extension of an object beyond its boundaries, and the cutting

of this vast continuum into distinctly framed fields.

Conventional Western writing and typography is organized on a **grid**:
a generic page consists of horizontal rows of type arranged in a rectangular block.
Van Doesburg foregrounded the **grid** of conventional typography by framing

fields of type with heavy bars. He also applied the grid to the alphabet,
translating its traditionally organic, continuous, individualized forms into discontinuous, repetitive elements.

Although van Doesburg was not invited to join the Bauhaus faculty,
he influenced the school by holding informal seminars in Weimar.
De Stijl principles are evident in the typography produced at the Bauhaus by
Laszlo Moholy-Nagy, Josef Albers, Herbert Bayer, and Joost Schmidt.

As described by Saussure, language is also a kind of **grid**:
language articulates the *"uncharted nebula"* of pre-linguistic thought into distinct elements,

breaking down the infinitely gradated continuum of experience into repeatable signs.

Language is a **grid**, and a **grid** is a language.

**Figure 1** Texture exercise by W. Diekmann, 1922, a student of Itten. The exercise is described in a 1925-6 curriculum statement as ''Collecting and systematically tabulating samples of materials'' (Wingler 109). The exercise also appeared at the New Bauhaus in Chicago; Moholy-Nagy labelled one example ''Tactile chart / A dictionary of the different qualities of touch sensations, such as pain, pricking, temperature, vibration, etc.'' (68).

**Figure 2** Kandinsky described the four-square grid as the ''prototype of linear expression... the most primitive form of the division of a schematic plane'' (66).

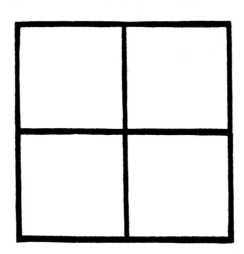

**Figure 3** Advertisements from the magazine *De Stijl*, 1921, published by Theo van Doesburg. The design foregrounds the grid structure of conventional typography; van Doesburg has inverted the last line, playing with established syntax.

**Figure 4** Moholy-Nagy's 1927 prospectus for *8 Bauhaus Books* shows the influence of de Stijl.

**Figure 5** De Stijl Alphabet, van Doesburg, 1917

**Figure 6** Stencil alphabet, Josef Albers, 1925

''Without language, thought is a vague, uncharted nebula... Thought, chaotic by nature, has to become ordered in the process of its decomposition. Language works out its units while taking shape between two shapeless masses.''

**Figure 7** Saussure writes that before the emergence of language, the realms of sound and thought are continuous, amorphous planes. Language functions like a grid, cutting up the ''uncharted'' continuum of experience into signs.

Figure 1

**figure** In the terms of Gestalt psychology, **figure** refers to an active, positive form revealed against a passive, negative ground.[1] In **Figure 1**, from an essay by the psychologist Wolfgang Kohler (1920), *"we see firm, closed structures 'standing out' in a lively and impressive manner from the remaining field... The narrower spaces are 'strips' while the area between them is mere ground"* (Ellis 36). Gestalt psychology addressed a basic problem in the science of perception: how are we able to make sense out of visual data, seeing distinct forms rather than a chaotic jumble of colors? Gestalt theory challenged the belief that this ability is a learned skill, asserting instead that the brain *spontaneously* organizes sense data into simple patterns: seeing is a process of ordering. Many Gestalt experiments center on optical illusions, in which what we objectively *know* about an image is contradicted by how we *perceive* it: in **Figure 2** a group of separate marks *appears* to form a single coherent **figure**. The optical illusions of Gestalt psychology disproved the notion that perception is "learned" by revealing the discrepancy between objective knowledge and actual experience.

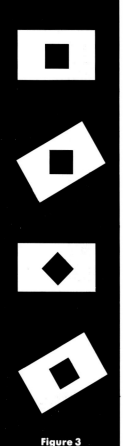

A series of lectures on Gestalt psychology was given at the Bauhaus in 1928. The lectures were well received, as they suggested a scientific basis for Kandinsky's and Klee's search for a universal visual script (Wingler 159-60). Gestalt psychology became central to modern design theory after WWII, which promoted an ideology of vision as an autonomous and rational faculty.[2] For example, Gyorgy Kepes's 1944 *Language of Vision*, written at the Institute of Design in Chicago (formerly the New Bauhaus), draws heavily upon Gestalt psychology. **Figure 3**, from Kepes's book, shows how a **figure** changes perceptually in relation to the ground that frames it, while **Figure 4** shows an ambiguous relation between **figure** and ground. Gestalt psychology has offered design a grammar of frames, demonstrating the ways that a **figure** emerges against a neutral ground, which itself recedes as the necessary but invisible condition of perception.

Figure 3

Figure 2

Yet while Gestalt theory foregrounds *perceptual* frames, it discourages thinking about *cultural* frames. The social, linguistic, and institutional contexts of design recede behind the dominant **figure** of form. In the language of publishing, a **figure** is an illustration appended to a document; it engages modes of framing which are textual as well as perceptual, suggesting questions like these: Is text a frame for images, or are images framed by text? How does the frame—*which appears to disappear*—mold the meaning of the **figure**?

Figure 4

1  Gestalt psychology was initiated by Max Wertheimer at the University of Frankfurt in 1912; he and his students Wolfgang Kohler and Kurt Koffka became its central theorists. See Willis D. Ellis, *A Sourcebook of Gestalt Psychology* (New York: Harcourt Brace, 1939); William S. Sahakian, *History and Systems of Psychology* (New York: John Wiley and Sons, 1975) 198-221; and Nicholas D. Pastore, *Selective History of Theories of Visual Perception, 1650-1950* (New York: Oxford University Press, 1971).
2  The most popular protagonist of an aesthetics based on Gestalt psychology has been Rudolf Arnheim. See *Art and Visual Perception* (Berkeley: University of California Press, 1954; revised 1974).

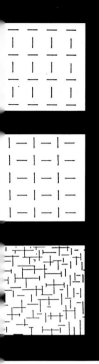

**Figure 5**, from Kepes's *Language of Vision*, consists of three consecutive graphics: a representation of a Mondrian painting follows two didactic drawings demonstrating the perceptual law that similar elements tend to consolidate into groups. Kepes has brought together two divergent cultural discourses within a single frame: science and art. By using technical diagrams as models for artistic practice, Kepes has shifted them from their role as *secondary* support for a verbal argument to *primary* figures in their own right. Science is aestheticized by its association with art, while art borrows a sense of authority and explanatory power from science. Perceptual diagrams offered Kepes attractive formal qualities—abstraction, simplicity, typographic linearity. He also placed aesthetic value on their *function*, their role as direct manifestations or indexical records of the laws of vision. Diagrams from Gestalt psychology have no ''meaning'' or signified, but rather a function: *to be seen*. Perceptual diagrams are elementary sentences written in the language of vision.

**Figure 6** demonstrates another perceptual principle: at the intersections of a grid, the negative space becomes active, beginning to solidify into rectangular figures. In addition to its *formal* ambiguity, Kepes's figure is *conceptually* ambiguous: it is at once figure and frame, theory and practice, science and art, perceptual diagram and Mondrian grid.

''Perhaps the only entirely new and probably the most important aspect of today's language of forms is the fact that 'negative' elements (the remainder, intermediate, and subtractive quantities) are made active...'' Josef Albers, ''Creative Education,'' *Sixth International Congress for Drawing, Art Education, and Applied Art*, Prague, 1928 (Wingler 142)

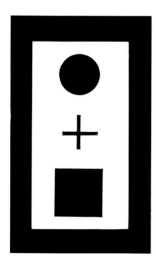

**Figure 7** Kasimir Malevich's *Suprematist Elements* is reproduced in Kepes's *Language of Vision*, appearing in a sequence that ends with examples of contemporary commercial art. During the 1940s various American designers incorporated the formal principles of avant-garde art into their work, often in an eclectic manner; Paul Rand, for example, borrowed from both Constructivism (**Figure 8**) and Surrealism. Kepes describes this process of incorporation in purely perceptual terms:
''The research in movements, stresses, and tensions on the picture surface have had [sic] a great influence on the applied arts. Designers of posters and window-display explored the newly discovered idioms and changed their methods from a static symmetry to an elementary dynamic balance'' (112).
The use of the historical avant-gardes as a source of formal vocabularies remains a common strategy among designers today; yet as Mike Mills argues in his essay in this monograph, the meaning of style is not inherent to its form, but changes with its cultural context.

a design students' guide
to the New York World's Fair
compiled for
P/M magazine . . . by Laboratory School
of Industrial Design

Verwenden
Sie das
Qualitätspapier
Hard-Mill
Feldmann, Dutli & Co. Zürich

Verwenden Sie das

Qualitätspapier

Feldmann,
Dutli & Co.
Zürich        Hard-Mill

Verwenden Sie
das Qualitätspapier Hard - Mill
Feldmann,
Dutli & Co.
Zürich

Verwenden Sie
das
Qualitätspapier

Hard-Mill

Feldmann
Dutli & Co. Zürich

**post script**

A *language* consists of a vocabulary of signs combined according to grammatical laws. A recurring strategy of modernist design pedagogy is to repetitively arrange and rearrange a collection of marks according to given rules of combination. The compositions above, redrawn from an anonymous student exercise produced in 1930, resemble numerous later explorations of the language of vision, found in such post-avant-garde textbooks as Armin Hofmann's *Graphic Design Manual* and Emil Ruder's *Typography*.[1] The dominant task of modern design theory has been to uncover the *syntax* of the language of vision: that is, ways to organize geometric and typographic elements in relation to such formal oppositions as orthogonal/diagonal, static/dynamic, figure/ground, linear/planar, and regular/irregular.

Switzerland emerged as the ideological center of modern design theory in the 1950s and 60s: the phrase "Swiss design" became equated with the systematic deployment of typographic elements in a gridded space, as in the studies above, from a series in Emil Ruder's *Typography* (1981). Although Swiss modernism is commonly associated with anti-individualism, intuition is a key element in such rationalist equations as this statement from Karl Gerstner's *Designing Programmes* (1963): "*The more exact and complete [the] criteria are, the more creative the work becomes. The creative act is reduced to an act of selection.*"[2] Thus for Gerstner, a set of rules functions as a decision-making machine that submits a vast series of choices to the designer's final act of judgment—the process is rational, but only until this decisive moment of personal intuition.

1 Emil Ruder, *Typography* (New York: Hastings House, 1981).

2 Karl Gerstner, *Designing Programmes* (Zurich: ABC Verlag, 1963) 9.

By the early 70s, the apparently contradictory union of rational system and intuitive choice had become a central concern for some designers working in the modernist idiom. Since 1968 Wolfgang Weingart, teaching at the Basle School of Design, has focused on the intuitive side of the modernist equation, rejecting the ideal of objectivity in favor of inventive self-expression. Yet while Weingart's design *looks* fundamentally opposed to the older rationalism, he sees it as the logical extension of the ideas of Hofmann, Gerstner, and Ruder, whose seemingly objective work was always based, in the end, on intuitive choices.[1] Weingart had a major impact on the refined formalism of the 1970s and 80s, which foregrounds the decorative potential of the modernist syntax rather than using it as a neutral envelope.

The exercise above, from Cranbrook's graphic design program, introduces vernacular typography into Ruder's systematic grid study; its purpose is *"to build a personal mythology."*[2] What alternatives are there to the neo-modernist project of *personalizing* modernist languages, apart from a return to the untenable ideal of universal, value-free communication? The limited formal vocabularies of de Stijl and Constructivism, the ready-made objects of Marcel Duchamp, and the political montages of John Heartfield can be seen as attempts to expose a linguistic, cultural, or psychological order which legislates the individual creative act. Rather than personalize modernism, we could foreground the power and pervasiveness of the languages we use—visual and verbal, private and public, abstract and conventional.

1 Wolfgang Weingart, "How Can One Make Swiss Typography?" *Octavo* 87.4 (1987).

2 Katherine and Michael McCoy, *Cranbrook Design: The New Discourse* (New York: Rizzoli, 1990) 38.

# The Birth of Weimar

Tori Egherman

"This is more than
just a lost war.
A world has come
to an end.
We must seek a
radical solution
to our problems."
Walter Gropius
1918[1]

"Germany is not
looking to Prussia's
liberalism but to
her power…
The great questions
of the day will not
be decided by
speeches and majority
decisions…
but by iron and
blood."
Bismark, leading
Germany into war
1871[2]

In the nineteenth
century, Great Britain
reigned as the world's
leading exporter of
iron. In the 1870's
England produced 4 ½
times as much iron as
Germany. By 1914,
however, Germany's
iron production
equalled all that of
France, Britain and
Russia combined.

In its 15 years, the
Weimar Republic had
17 governments.
The revolution never
ended.

On the eve of defeat in World War I, the Kaiser abdicated, and a Republic, with its capitol in Weimar, was formed. The young republic had to negotiate peace with its enemies from without and from within. Disappointment with the Kaiser and the insistence on fighting a war with no hope of victory caused the troops to mutiny. Having entered the battlefield confident and full of moral superiority, the Germans emerged feeling defeated and betrayed.

In a ceremony designed to humiliate the French, Wilhelm I, King of Prussia, proclaimed himself the Kaiser of Germany at Versailles in 1871. The forty-seven years that had followed the unification of the German nation saw it develop from a "geographical assemblage" into the most industrialized and militarized nation in Europe. According to Modris Eksteins, it was the spiritual link Germans felt with production that made this possible. In *The Rites of Spring*, he states that "efficiency became an end, not a means. And Germany herself became the expression of an elemental 'life force.' Such was the stuff of German idealism."

With its speed of urbanization and industrialization, Germany shared more characteristics with America than with the rest of Europe—travellers often compared Berlin and Chicago because of its rapid growth, new architecture, and shared youthfulness. The arts were thriving in Germany. Diaghilev, whose productions had met with animosity in the other European capitols, was welcomed in Berlin. The largest Socialist Party in Europe made its home in Germany. There were active womens' and homosexuals' rights groups throughout the country. Fad diets were popular, and people frequented nudist camps.

German confidence had turned sour by the end of the war. Although a republic had been born of German dissatisfaction, it was a republic that never captured the German spirit. As early as 1920, Weimar's supporters suffered major losses in the Reichstag elections: the government was called "a Republic without republicans."[4] Socialists fought with other Socialists; Communists refused compromise. There was no central party to guide the country through the crises awaiting it. Many government officials and industrialists remained sympathetic with the old regime and worked to undermine the new.

In 1871, the
population of Berlin
was fewer than
100,000, but in a few
short years it grew to a
city of over one
million.

"Faune encored.
Ten calls. No protests.
All Berlin present.
Strauss, Hofmann-
sthal, Reinhardt,
Nikisch, the whole
Secession group,
King of Portugal,
ambassadors
and court… Press
enthusiastic…"
Diaghilev, Berlin
1912[3]

In 1910, Berlin had
over 40 gay bars.

1 Quoted in Peter Gay,
*Weimar Culture:
The Insider as Outsider*
(New York: Harper
and Row, 1970) 9.

2 Quoted in Donald
Kagan et. al.,
*The Western Heritage*,
Volume II (New York:
Macmillan, 1987) 771.

3 Modris Eksteins,
*The Rites of Spring:
The Great War and the
Birth of the Modern Age*
(Boston: Houghton
Mifflin, 1989) 76.

4 See Ian Kershaw,
ed., *Weimar: Why Did
German Democracy Fail?*
(New York: St. Martin's
Press, 1990) 20.

Hyper-inflation was welcomed by the Republic's detractors with the hope that it would destabilize the Republic.

Hugo Stinnes, the Rhennish mining magnate, encouraged the Reichsbank to print more money. By 1923, 300 paper mills and 2000 printing presses working twenty-four hours a day could not make enough money to keep up with the inflation.

In November of 1923 a roll cost 20 billion marks, a newspaper 50 billion. The mark was at one trillionth its pre-war value.

Low-denomination currency was so worthless, it was withdrawn from circulation. Here, children use them as building blocks, 1923.

# 2000000

## ZWEI MILLION MARK

**WEIMAR, DEN 9. AUGUST 1923**
**DIE LANDESREGIERUNG**

2000000 Mark zahlt die Kasse der Thüringischen Staatsbank dem Einlieferer dieses Notgeldscheines. — Vom 1. September 1923 ab kann dieses Notgeld aufgerufen und gegen Umtausch in Reichsbanknoten eingezogen werden.

Wer Banknoten nachmacht oder verfälscht oder nachgemachte oder verfälschte sich verschafft und in den Verkehr bringt, wird mit Zuchthaus nicht unter zwei Jahren bestraft.

Herbert Bayer frantically designed two and three million mark Reichsbank notes in 1923. They were put into circulation before the ink had a chance to dry. Photo courtesy Denver Art Museum.

The Treaty of Versailles cost the Germans 13 percent of their pre-war territory, causing them to lose 15 percent of their arable land and 75 percent of their iron ore deposits. In 1919, industrial strength reached only 42 percent of its 1913 level.

The Kaiser had financed the war on credit, expecting to exact war damage costs from the defeated Allied forces. Karl Hardach writes that ''as late as May 1917, the Kaiser daydreamed of $30 billion each from the U.S. and the U.K. and about $7 billion from France.''[1]

The spirit of Weimar was set by the Treaty of Versailles, signed in the very palace where Wilhelm I had declared himself ruler of the new Germany less than fifty years earlier. The German democratic representatives, demanded by President Wilson, suffered the blame for the terms of surrender. The treaty put an already shaky republic in even more danger from both left- and right-wing opposition.

Illegitimacy translated into political assassination. Socialist and Communist journalists and politicians found themselves impotent against the courts. Despite the exposés and documents produced by the left, the courts continued to be easy on the right and hard on the left. E. J. Gumbel, a statistician who collected information about crime and murder, found no friendly ears in the courts. "One prosecution after another is begun," he wrote. "Each has its own structure. Only the result is *the same*: the true murderers remain unpunished" (Gay 20-24). Adolph Hitler, who should have been deported for his role in a coup attempt, was sentenced to just five years in prison and served only one. He was allowed to stay in Germany because he "thought" himself a German. The nation was in a state of moral and ethical disintegration that caused an already mystical people to search for meaning and unity, a return to "das Volk." It was said that "Jews and Communists" had undermined the victory of the German forces.

Writing that after years spent as a soldier on the front lines he was ready to "start building [his] life anew," Walter Gropius signaled his desire to head the Arts and Crafts School in Weimar. In the chaos that was the German world, there was hope that through a new art, a new order could be created. Gropius called for a unification of the arts: "The old schools of art were unable to produce this unity," he wrote. "How could they, since art cannot be taught? They must be merged once more with the workshop..." (Wingler 26).

It is the tragedy that followed the demise of the Weimar Republic that makes its study so compelling. Like a knife blade with its potential to serve both good and evil, the appeal to the German mythic character was drawn upon by both liberals and fascists. The absence of a convincing German republic invited a search for spirituality that led not only to such utopian moments as the Bauhaus, with it humanitarian aims, but also to the devastation wrought by the Nazis.

1 Karl Hardach,
*The Political Economy of
Germany in the
Twentieth Century*
(Berkeley: University
of California Press
1976).

2 Ray Stannard Baker,
*An American Chronicle*
(New York: Charles
Scribners, 1927) 406.

3 Gordon A. Craig,
*Germany 1866-1945*
(New York: Oxford
University Press, 1978)
435.

4 Hans Wingler,
*The Bauhaus*
(Cambridge: MIT
Press, 1969) 31.

## Herbert Bayer's Universal Type in its Historical Contexts

Mike Mills

"today we do not build in gothic, but in our contemporary way"

"no longer do we travel on horseback, but in cars, trains and planes"

"we do not dress in crinolines nowadays, but in a more rational manner"

Quoted from Bayer's 1938 essay "towards a universal type"[1]

With the defeat of the German empire in the First World War, the legitimacy of nineteenth-century culture appeared bankrupt. Many Germans felt they had to start fresh again. Progressive designers, such as those associated with the Bauhaus, promoted a new way of thinking about vision and the function of the visual environment.

"What if the idea of progress were not an idea but rather a symptom of something else?" **Frederic Jameson**[2]

They argued that design should no longer be used to reflect and reinforce a hierarchical society. Sibyl Moholy-Nagy, spokesperson of the Bauhaus approach, stated that "a new code of visual values" had to be created, that would "spit in the face of the harmonious image which had hidden decay, deceit, and exploitation."[3] Many members of the Bauhaus believed the future rested in "universal" laws of reason, which were detached from the confines of traditional culture.

Herbert Bayer was a student at the Bauhaus from 1921 to 1923; in 1925 Walter Gropius invited him to head the typography and printing workshop. Bayer played a major role in developing a "new typography," which used sans-serif type, heavy rules, and systematizing grids to create clean and logical compositions. Bayer hoped to transcend the transient whims of culture by basing his designs on timeless, objective laws. Considerations of style and self-expression were subordinated to the "purity" of geometry and the demands of function. This method culminated in Bayer's attempt to design a typeface with letterforms so "essential" they would be understood as universal.

The typeface "universal," designed by Bayer in 1925, represents a reduction of Roman letterforms to simple geometric shapes. To Bayer, the Roman characters were the basic typographic forms from which all subsequent styles were developed. Bayer's preference of Roman type over the more "German" Gothic style indicates his attempt to create a legible, international typeface. Yet Bayer felt that geometric reduction would "refine" the Roman letterforms.

This essay uses the grid to break up the self-contained body of text, allowing different voices and figures to penetrate and interrupt the linear progression of meaning.

abcdefghi
jklmnopqr
stuvwxyz

wir beabsichtigen eine serie
verschiedener seifen in weis
sen kartons....

aa bb cd eeffgyy
hijkk lmnoop
qrrsstu vw xæyzz

**Left:**
Universal was not merely a typeface but a complete writing system designed for print, typewriter, and hand use.

1 Herbert Bayer, "towards a universal type," *PM* 6.2 (Dec. 1939 · Jan. 1940): 1-32.
2 Frederic Jameson, "Progress Versus Utopia; or, Can We Imagine the Future?" ed. Brian Wallis, *Art After Modernism* (New York: The New Museum of Contemporary Art, 1989) 239.
3 Sibyl Moholy-Nagy, *Experiment in Totality* (New York: Harper and Brothers, 1950) 2.

In this 1938 diagram, Bayer outlined the historical progression and eventual "rationalization" of the letterform. The diagram shows that Universal's distinctive **a** refers to the Greek a, reflecting Bayer's intention to uncover the foundations of Western letterforms rather than inventing new letterforms.

Since most type was produced by machines, Bayer argued that it was unnecessary to imitate the incised line of the chisel or thin up-stroke and thick down-stroke of the pen. Universal's letterforms are composed of geometrically defined lines of uniform width; the **o** is a perfect circle, the **b** , **d** , and **q** consist of a circle and a vertical staff, and the **x** is created by connecting half-circles. Bayer replaced the gesture of the hand with the control and regularity of this "rationalized" typeface.

To better understand how these formal qualities were defined as "universal," it is necessary to acknowledge the historical context in which they were created. Stuart Ewen, a cultural historian, describes how the nineteenth century saw an increasing separation between the treatment of the *surface* and the *structure* of designed objects.[1]

"By the 1830s, the term *design* was assuming a modern definition, describing the superficial application of decoration to the form and surface of a product. The notion of decoration was becoming more and more distinct from the overall plan of production" (Ewen 33).

Mass production and a mobile market economy encouraged the production of heavily ornamented yet cheaply fabricated products. Affordable manufacture allowed the burgeoning middle class to acquire "luxury" goods fashioned after objects formerly reserved for an elite.

The separation between surface and structure is reflected in design which dresses up in historical references and aristocratic styles. Technical advances in lithography and wood type enabled extravagantly ornamented letter design.

**MELONS**

Fonts such as Melons, Marbleized, and Delighting, used in the 1880s, demonstrate how the structure of letterforms could be covered with

**DELIGHTING**

**MARBLEIZED**

ornamentation, fulfilling the demand for more eye-catching advertising. The nineteenth-century fascination with illusion and artificiality is reflected in letters which masquerade as marble, fruit, wood, or other materials. Towards the end of the century, typefaces appeared which reacted against the superficiality and "poor" craftsmanship of such decorated typography. The typeface Chaucer, designed by William Morris in 1891, reflects the desire to return to the skilled hand of the individual craftsman. Its calligraphic forms were derived from Gothic lettering, indicating the symbolic

**Chaucer**

**ECKMANN**

value of Gothic artifacts to Morris's Arts and Crafts Movement. Otto Eckmann's 1901 face Eckmann-Schmuck shows the influence of Art Nouveau and Jugendstil. These typefaces appealed to an abstract "organicism" which did not mimic natural objects, as with the ornamental face Melons, but attempted to embody the spontaneous, fluid qualities of natural processes. The sensuous and idiosyncratic contours of Eckmann-Schmuck symbolize a rejection of the increasingly mechanized and urban world.

1  Stuart Ewen, *All Consuming Images: The Politics of Style in Contemporary Culture* (New York: Harper and Brothers, 1988).

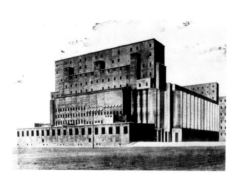

While Bayer rejected the pretentious ornamentation of nineteenth century design, he was not satisfied with returning to an "outmoded" crafts tradition or a "romantic" conception of nature. Universal type embraced industry and technology; it adopted the techniques of mass production and the rationalized methods of the engineer. Universal type is part of the larger Bauhaus project of uniting the artist with industry. Gropius, founder of the Bauhaus, claimed that only such unification would yield affordable and "essential" products.[1]

Gropius and many other European designers were heavily influenced by the visual language of American industry. Gropius collected photographs of American grain silos and other structures, which he believed were free of the influence of the past.
Gropius wanted to be the "Ford of Housing";[2] his aestheticized and idealized understanding of American industry focussed selectively on those qualities which echoed his own ideas on the aesthetics of the future.

This faith in technology reflects the influence of "Americanism," a movement which swept across Europe after the First World War, motivating modernist designers such as Bayer, Gropius, and Le Corbusier. Americanism, as represented in the production techniques of Henry Ford and the "scientific management" theories of Frederick Taylor, promised a new way of living and producing characterized by "rationalization" and the lack of "enslaving" traditions.

While many Europeans in the early twentieth century believed that America was "traditionless" and separate from their own culture, **Antonio Gramsci** has argued, in contrast, that the culture of the United States was "an organic extension and an intensification of European civilization, which has simply acquired a new coating in the American climate."[3]

The imaginations of progressive Europeans were excited by such books as *Der Tunnel* (1913), which described the construction of a tunnel under the Atlantic Ocean, connecting the new and old worlds via the wonders of American engineering. *Der Tunnel* embodies the modernist belief that progress was synonymous with an increasingly homogenous and universal culture shaped by the efficiency of the engineer. America represented a living example of the future to many Europeans.

The visual and theoretical grammar of Universal type developed in this cultural and historical context. Like the automobiles produced on Henry Ford's factory line, Universal's letterforms were designed on a "rationalized" plan.

"The engineer, inspired by the law of economy and governed by mathematical calculation, puts us in accord with universal law."
**Le Corbusier**[4]

Each character was engineered on an "armature" consisting of a few circles and arcs, three angles, and horizontal and vertical lines. These formal features reflect Bayer's theoretical position: technology was held to be, as Sibyl Moholy-Nagy stated, "unadulterated by man and his perverted symbolism" (3). The scientific foundation of mechanization would cleanse typography of superfluous cultural styles. Bayer avoided all suggestions of calligraphy by constructing lines with the compass, T-square, and angle. In Bayer's words, the freedom traditionally enjoyed by the type designer was "responsible for so many mistakes" (Bayer, "towards a universal type," 29).

Bayer's clean geometric armature aimed to rationalize the design of letterforms.

1 Walter Gropius, "Program for the Funding of a General Housing-Construction Company Following Artistically Uniform Principles, 1910," ed. Hans M. Wingler, *The Bauhaus* (Cambridge: MIT Press, 1978) 20.
2 Wilfred Nerdinger, "Walter Gropius—From Americanism to the New World," *Walter Gropius* (Berlin: Gebr. Mann Verlag, 1985) 16.
3 Antonio Gramsci, "Americanism and Fordism," *Prison Notebook* (New York: International, 1971) 318.
4 Le Corbusier, *Towards a New Architecture*, trans. Frederick Etchells (New York: Dover, 1986) 1.

**stencil**

One of several experimental designs for the Futura G

Contemporary designers such as Joseph Albers and Paul Renner shared Bayer's advocacy of "rationalized" typographic construction. Albers's "stencil typeface" (1925) is "built-up" from a few forms, giving the typeface a regularity and simplicity which Albers thought to be the "essential" core of the letterform, purified of subjective intentions. The original design for Renner's typeface Futura (1928) is based on the forms created by the compass, T-square, and triangle. The *G* exemplifies the translation of a conventional letterform into a geometric language. Futura's schematic characters rejected the nuances of traditional type design methods in favor of the rigidity of mechanical construction.

**Below**: One of Renner's 1928 drawings for Futura, and the version which the Bauer Company produced.

futura
**Futura**

$A + a = a$

The influence of Americanism is also reflected in Bayer's attempt to create a more efficient typeface. universal type was designed only in the lowercase alphabet. bayer argued that since speech does not recognize capital letters, they are no longer needed in typography. a single-case alphabet would be easier for children to learn, and more efficient to write. the lack of uppercase letters would reduce the printer's storage space, set-up time, and overall costs. bayer's concern for the efficiency of his design reflects the concerns of the "scientific management" movement, also known as "taylorism." frederick taylor, an american managerial theorist known as the "efficiency engineer," timed workers' movements and analyzed their relation to tools in order to establish a universally efficient order of operations. taylor's project was, like universal type, based on the belief in an objective and universal law, which rests at the foundation of any problem.

While other designers shared Bayer's attempt to rationalize typography with a single-case alphabet, they often came to contradictory results, revealing the subjectivity within these "objective" rules. Jan Tschichold's Universal type of 1926-29 echoes Bayer's typeface, but combines elements of both the upper- and lowercase to create a single-case alphabet.

Jan Tschichold's Universal type, 1926-29

universal

Tschichold also experimented with replacing sound groups with typographic symbols and standardizing spelling to match consistently the sounds of speech. A. M. Cassandre's typeface Peignot (1937) and Bifur (1929) directly contradict Bayer's experiment by creating a single-case alphabet in capital letters. Peignot's original type specimen stated that lowercase letterforms "will soon come to seem as archaic as the shapes of Gothic characters."

Bradbury Thompson continued Bayer's experiment with his monoalphabet (1940), which uses only lowercase letters, increasing their size to indicate the beginning of sentences and proper nouns. Thompson's Alphabet 26 (1950) attempted to create a single-case alphabet by combining the seven letters which have the same symbol in both cases (illustrated at right in blue letters) with four lowercase letters (in red) and fifteen uppercase letters (in black).

Bradbury Thompson's Alphabet 26, 1950

a B C D e
F G H I J K
L M n O P
Q R S T U
V W X Y Z

Bayer stated that the "typographic revolution was not an isolated event but went hand in hand with a new social and political consciousness and consequently, with the building of new cultural foundations."[1] Many modernist designers saw industry as a potential leveler of the inequalities of Europe's feudal heritage.

Laszlo Moholy-Nagy stated, "everyone is equal before the machine... there is no tradition in technology, no class consciousness" (S. Moholy-Nagy 19). Bayer's faith in technology is based on the belief that culture is "artificial,"

While technology was understood as an agent of progress to Moholy-Nagy and other Bauhaus masters, many of their contemporaries saw the machine as a monstrous threat to society and the individual. To the Expressionists, for example, memory of the First World War's military technologies inspired only fear of the industrialized society. This still from **Fritz Lang**'s *Metropolis* (1928) represents the machine as a devouring, dehumanizing, and undemocratic means of production. These opposing views of technology are integral to the Weimar era, and both were represented at the Bauhaus. Gropius's famous statement, "Art and technology, a new unity" received much criticism from voices within the school. For an analysis of the connotations of the machine in the Weimar era, and their expression in *Metropolis*, see **Andreas Huyssen**'s "The Vamp and the Machine."[2]

while reason and science are "pure." He considered the simple, geometric letterforms to be socially liberating, because they did not hide behind illusionistic or aristocratic styling. Universal type was thought to be, like the machine, "naked" of embellishment and empty of cultural ideology.

Yet while Bayer developed this "naked" visual language, he was also capable of working in a more stylized method. In 1933 the Berthold Type Foundry commissioned Bayer to design a typeface for commercial use. The result, Bayer Type, is like Universal in that it is constructed with geometric shapes, but it is adorned with serifs and made fashionable by the strong contrasts in the thicks and thins of the letterforms. This design was overtly styled, while the "rational" experiment—Universal type—was supposedly free of such "superficial" decoration. The contrast in these typefaces reveals that Bayer's definition of the essential letterform was also a repudiation of "style" and the influence of culture.

Initially, "modern" design found few clients who were willing to put its experiments into practice. The commercial success of the Bauhaus design style in the late twenties and thirties marks the dulling—rather than the acceptance—of its politically radical edge. While World War II made New York the new home of modernism, the often more pragmatic concerns of the Americans transformed the social and political implications of the original movement.

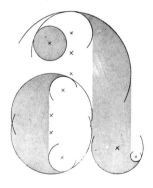

While both Universal and Bayer Type are geometrically composed, Universal is thought to be "naked" while Bayer Type is "dressed up."

1  Herbert Bayer, "On Typography," ed. Arthur Cohen, *Herbert Bayer* (Cambridge: MIT Press, 1984) 350.
2  Andreas Huyssen, "The Vamp and the Machine: Fritz Lang's *Metropolis*," *After the Great Divide: Modernism, Mass Culture, Postmodernism* (Indianapolis: University of Indiana Press, 1986) 65-81.

M. F. Agha, the art director of *Vogue* and a frequent contributor to design periodicals, stated in a 1931 article that the Europeans were accepted into the "temple of American graphic arts" because they were "such Attention Getters." Agha paints a pessimistic picture of the acceptance of European designers, stating that they were used because they could produce "Attention Value, Snap, and Wallop; while in their spare time they were allowed to indulge in innocent discussions about the machine age, fitness to function, and objectivity in art."[1]

By 1928, Bayer suggested that the "New Typography" had already been reduced to an "external appearance." Bayer cites the order book of a Frankfurt printer: "nearly half of all printing orders received in one year called for the work to be done in a 'Bauhaus style.'" Bayer added, "this meant being right back at the point of departure."[2]

After leaving the Bauhaus in 1928, Bayer was hired by M. F. Agha as art director for German *Vogue*. Through this work, Bayer became art director for the prestigious Dorland Studios in Berlin. In 1938 Bayer emigrated to New York, where he was consultant to J. Walter Thompson in 1944, and art director of Dorland International, 1944-6. Through his commercial success at these firms, Bayer became a consultant designer to the Container Corporation of America, and in 1956 he became chairman of the department of design for the CCA.[3]

While the subject of this essay, Universal type, represents a rationalized and disciplined methodology, Bayer was a pragmatic designer, who experimented in a variety of styles and mediums. This advertisement, designed by Bayer at the Dorland Studios, reveals that he did not confine himself to a single dogmatic approach to design, but worked in a variety of styles such as this surrealistic photomontage (1935). This contradiction was not an issue to Bayer; he stated, "any method which best solves a specific problem is acceptable"[4]

Bayer's work for the CCA exemplifies the successful integration of the "Universal" approach with corporate ideology. The CCA was a pioneer in the creation of cohesive corporate identity. As Universal's characters were made regular by the armature on which they were constructed, the corporate identity followed a centralized plan.

The architecture and the office furniture, the paint on the walls and the trucks, the typography on the checks, letterheads, annual reports, invoices, and advertisements, were planned as a cohesive body. Bayer's 1952 essay "Design as an Expression of Industry" describes the CCA identity as a "function of management" used to control the opinion of employees, customers, and the public.[5]

The CCA logo program (**right**) was developed by Egbert Jacobson in 1931. Its standardized visual language homogenized the many cultures encountered in multi-national corporate expansion.

In 1966 Bayer took on his largest corporate assignment as art director for the Atlantic Richfield Corporation (ARCO). Bayer designed or selected the architecture, carpet designs and tile patterns, murals and signage, public sculptures, typography and advertising, as well as collecting art for the corporation. As with the CCA, Bayer used his rationalized, "total design" approach to endow ARCO with the aura of transcendent regularity: a quality which visually expressed the authority of a multinational corporation.

1  M. F. Agha, "Graphic Arts in Advertising," *American Union of Decorative Artists and Craftsmen*, ed. R. L. Leonard et. al. (New York: Ives Washburn, 1931) 139.
2  Herbert Bayer, "Typography and Commercial Art Forms," originally published in *Bauhaus Journal* Vol. 2, No. 1 (1928). Reprinted in Wingler, 135.
3  See Gwen F. Chanzit, *Herbert Bayer: The Collection and Archive at the Denver Art Museum* (Seattle: University of Washington Press, 1988).
4  Bayer, "an acceptance speech (1969)," in Cohen, 359.
5  Bayer, "Design as an Expression of Industry," *Gebrauchsgraphik* 9 (1952): 57-60.

While never realized, Bayer's roadside beautification installations for ARCO illustrate how Bayer was responsible for managing the visual impression of the corporation. Ironically, this project also reveals that while modernism was inspired by an aestheticized image of American industry (see Gropius's photograph of a grain silo), modern design would later be used to "beautify" the actual, unromanticized reality of American industry.[1]

While Bayer's "Bauhaus style" design once represented a critical alternative to established values, it has become, in its corporate use, an official bureaucratic language. Bayer's ARCO and CCA work reveals the inherent contradictions in the politics of Bayer's design theory. Bayer aspired to dispel the class distinctions and social inequities in traditional European culture by homogenizing visual language. Bayer did not recognize that the homogenization of language also homogenizes experience and culture. The broad levelling of class difference which Bayer hoped to achieve through rationalized design encourages the elimination of indigenous and individual voices in favor of a centralized visual vocabulary.

Bayer's typeface has been employed in what Roland Barthes would call the "mythologies" of the corporation: its meaning has become a "tamed richness" which the corporation "holds at its disposal." While designers in the 20s focussed on the politically liberating potential of the new visual language, corporate designers shifted the focus to foreground the formal regularity and stability in order to visually substantiate their authority. This "shift" in focus does not, as Barthes would say, "obliterate" the former meanings assigned to the design, but rather "distorts" them so that they work for the ideology of the corporation.[2] What once symbolized change now symbolizes permanence.

ʌn ʌlfʌbet ko-ordinʌtη fonetiks ʌnd visʌn wil̦ be ʌ mor efektiv tul uf kumunikʌtʌn

During his tenure as chairman for the design department of CCA, Bayer resumed his experimentation with language, this time in the form of the Basic Alphabet. While Universal type was a revision of established letterforms, the Basic Alphabet attempted to reorganize writing itself. Bayer created phonetic symbols to take the place of double-letter sounds such as *ch*, *th*, and *sh*, and to replace "sound groups" such as *-ed*, *-en*, *-ion*, *-ng*, and *-ory*. Basic Alphabet omits letters with hidden sounds— "certainly" becomes "sertnly"—and created letterforms to express the variety of sounds conventionally assigned to a single letter. Basic Alphabet reflects the intentions behind the design of Universal type: the reduction and simplification of writing will create a more efficient, progressive, and democratic language.[3]

Paul Rand's 1962 logo for the American Broadcast Corporation exemplifies the use of modernist design by a large corporation. Rand used a variation of Universal type to create a logo distinguished by geometric refinement and the repetition of the circle. The clean, regular shapes of the letterforms translate into the regular, unified, stable authority of the corporation. While geometric design was once allied with a reevaluation of society, it is used in the ABC logo to reaffirm the stability of the organization.

1 See Arthur Cohen, *Herbert Bayer* (Cambridge: MIT Press, 1984).
2 Roland Barthes, "Myth Today," *A Barthes Reader*, ed. Susan Sontag (New York: Noonday Press, 1982) 73-150.
3 Herbert Bayer, "Basic Alphabet," *Print* (May/June 1964): 16-20.

Contrary to the claims of the original modernist designers, the meaning of a typeface changes with each historical, cultural context it appears in. A variation of the once radical typeface Futura was smartly used by Chermayeff and Geismar Associates in their logo for the Mobil Corporation. Here, Futura's distinctive o, highlighted in red, represents Mobil's product—oil—with geometric perfection. The Mobil logo symbolizes a shift in the meaning of Futura: the progressive rationality which once symbolized a challenge to authority comes to symbolize the authority of the corporation.

**Mobil**

The meanings of Bayer's Universal type do not merely fluctuate between "radical" and "corporate" connotations. A version of Universal appears in Vignelli Associates' logo for Bloomingdale's, where the letterforms take on an opulence and extravagance that contradicts the formerly puritanical intentions of the design. The thin line weight and interlacing *O*'s help to shift the focus onto the more decorative aspects of the typeface. These "stylized" features complement the connotations of shopping, fancy consumer goods, and the facade of prestige which the department store projects.

bloomingdale's

ITC **Bauhaus**

In 1974 the International Typeface Corporation redesigned Universal and renamed it Bauhaus. While this version is widely used, it does not embody the geometric rigor or simplicity of the original drawing.

When used in the context of popular culture, such as the credits for the hit TV show *Roseanne*, the typeface takes on other meanings even more remote from Bayer's original intentions. The geometry and heaviness of the letterforms become entwined with the bold, frank humor of this large, funny woman.

Bayer did not recognize his conception of universality to be the product of his culture and history. He believed the design resulted from natural rather than culturally constructed laws. This obscures the actual influence of social, economic, and political factors which surrounded and shaped Bayer's understanding of a "universal" typeface. Is the design a

manifestation of universal laws of visual language, or rather the visualization of *an idea of universality* specific to Weimar Germany? The history of Universal type reveals that the typeface was a "symptom" of a historical fissure—reflecting the collapse of nineteenth-century cultural values and the birth of a new and more "rationalized" world. History also reveals that the meaning of the typeface is not intrinsic to its form, but is continually recreated. Post-WWII corporations, for instance, have used variations of Universal type and Bayer's rationalized design method to make the corporation's *culturally* constructed authority appear *natural*, "a matter of fact." The meaning of Universal type is mediated by the people and institutions that use it.

# Appendix: The Gender of the Universal

Mike Mills

Western culture has constructed a dichotomy between what it labels as the ''objective'' quality of masculinity and the ''subjective'' quality of femininity. This mutually exclusive definition of gender has its analogue in Bayer's attempt to create a purely objective design which attempts to exclude, and deny, the presence of subjectivity. This appendix relates Sigmund Freud's theory of family power relations to Bayer's design methodology to show how these cultural beliefs about the meaning of masculine and feminine are developed, and to reveal that Bayer and Freud located reason and progress in the discipline and order personified by the father figure.

**Mother**: Freud believed that the mother ''engulfs'' the growing identity of the child with her nurturance. The child's total dependence on the mother in the first years of life renders him/her unable to differentiate the boundary between ''self'' and ''mother.'' The child is unable to distinguish between its interior world and the exterior world. Freud argued that the child, especially the male child, must ''repudiate'' the mother in order to become autonomous and self-governing: ''her nurturance threatens to re-engulf him with its reminder of helplessness and dependency; it must be corrected by his assertion of difference and superiority.''[1] Freud labeled the mother as regressive: the child who remains bound to her is locked in a self-involved and narcissistic world.

**Father**: Freud reinforces the common cultural belief which labels the mother as subjective and the father as objective. Freud believed that the father personifies objectivity because he brings external, social rules into the private, symbiotic relationship of the mother and child. The father grants the child a ''way into the world'' by asserting boundaries between the child and mother, and by inserting social norms the child must follow. He embodies an authority which Freud understood to be rational and progressive, and which the child both fears and admires. The child internalizes this ''law of the father'' in the form of the ''super-ego'': this is the agency which governs the ego, forcing the child to renounce the desire to stay united to the mother and enabling him/her to become self-governing.[2]

**History**: Just as Freud believed the progress of the child depends on rejecting the mother, Bayer believed progress in design could only be achieved by rejecting the oppressive and ''maternal'' history of European culture. Modern design reacted to the self-aggrandizing, overly ornamented design of the nineteenth century: a tradition which Bayer believed to be deceitful, and—like the child who has not individuated from its mother—narcissistic. The customs of the past had to be rationalized. The need to differentiate from the mother, which Freud believed is integral to the male ego, is played out in the modernist rejection of and differentiation from the past: the child (modern design) rejects the mother (European history) and identifies with the father (American industry).

**Progress**: The demands of function work like a super-ego in the design of Bayer's Universal type. Just as the child becomes mature and responsible by internalizing the law of the father, Bayer believed that letterforms become socially responsible and progressive when the design internalizes the demands of function. Freud believed the child could only individuate from the mother by becoming objective, and similarly, Bayer believed typographic progress depended on finding objective, trans-cultural laws, which would guide the design out of the maternal arms of tradition and into the rational world of timeless laws. The dichotomy between mother and father in Freudian theory is echoed in Bayer's dichotomy between the ''objective'' law of progress and the ''subjective'' customs of the past.

1 Jessica Benjamin, *The Bonds of Love* (New York: Pantheon, 1988).

2 See Sigmund Freud, *Civilization and its Discontents* (New York: W. W. Norton, 1961).

Figure 1

**Feminine**: In 1896 social critic Gustav Le Bon reflected a popular prejudice when he stated that the modern crowd is irrational, volatile, and, ''like women, it goes at once to extremes.''[1] Similarly, the growth of machine-made commodities and such forms of mass entertainment as pulp fiction, advertising, and movies were labelled by defenders of ''high'' culture as an inauthentic, materialistic, and ''*feminine*'' threat to both traditional and modern forms of elite culture. ''The swamp of big city life''... ''The spreading ooze of massification,'' threatened to ''engulf'' the masculine high culture.[2] The boy's anxiety of being overwhelmed by the mother is re-enacted in high culture's fear of losing itself in the ''false dreams'' mass culture.

**Masculine**: While Universal type was designed for the masses, its appeal to (masculine) function over (feminine) form represents a correction of mass culture rather than an affirmation of it. The armature on which Universal was built functions like Freud's ''rational'' father: it represents a regulator that disciplines the letterform. The armature enabled the design to be based on objective rules that were exterior to the designer's personality and supposedly detached from the subjective and ''feminine'' realm of popular culture. It is this detachment which Freud believed the father embodies, and which Western culture aligns with masculinity. While this detachment is understood as neutral, it requires the *active* repudiation of subjectivity.

Figure 4

Figure 2

**Subjectivity**: The dichotomous thinking practiced by Bayer and Freud conflated dependence with irrationality. To be dependent on or influenced by the fluctuating and ''whimsical'' tastes of popular culture was to weaken the boundaries which make one autonomous and to contaminate the purity of detached reason. The over-abundance of fluctuating values of popular culture were treated as a threat to the stable, timeless authority of high culture and rational design. Design geared toward the undisciplined *appetite* of the masses rather than the refined *taste* of high culture was considered swamped in a materialisitic dream world reflecting the subjectivity and narcissism of the child who remains bound to its mother.

**Objectivity**: The ego boundaries which the child builds in the Oedipal stage make him/her autonomous from the mother. These boundaries are echoed in Bayer's dichotomy between popular culture and ''functional'' design, between a (regressive) history and a (progressive) future, and between (feminine) style and (masculine) rejection of style. The ''neutral'' objectivity which Bayer pursued can be reinterpreted as a reassertion of stable masculine ego boundaries and standards of ''good'' design in a world of rapidly changing values. Freud and Bayer invested belief in a science that is ''premised on a radical dichotomy between subject and object and where all other experiences are accorded secondary 'feminine status.'''[3]

Figure 3

1 Gustave Le Bon, *The Crowd* (New York: Penguin, 1981) 50.
2 Andreas Huyssen, *After the Great Divide*, 52.
3 Evelyn Fox Keller, *Reflections on Gender and Science* (New Haven: Yale University Press, 1985) 87.

Figure 1 From Corbusier, *Towards a New Architecture*, 1931.
Figure 2 From Herbert Bayer, ''towards a universal type,'' 1939-40
Figure 3 Self-portrait of Herbert Bayer's hand
Figure 4 From Herbert Bayer, ''towards a universal type,'' 1939-40

Bayer believed that the geometric reduction of a letterform, such as the circular construction of the form s, would make the typeface more functional and legible. Yet we can question whether ''function'' is an objective and indisputable constant, as Bayer and some other members of the Bauhaus conceived of it, or if it is an ever shifting and regionally defined phenomenon. Might Bayer's effort to create functional design actually be an attempt to assert what our culture understands as paternal order and rationality into a seemingly chaotic and undisciplined mass culture?

*Translation of Bayer's notes*

Basic form constructed with the same weight.

The Universal a reveals the steps by which the presence of the subjective hand is eradicated, along with non-functional forms. The objectivity which Bayer believed to lie in the geometric letterform (4, below) offered a radical disjunction with the fashionable, the subjective, and with what the heritage of Western thought has labeled as the ''feminine'' whims of culture.

*Translation of Bayer's notes*

1 One weight—
  basic form
2 Circle and line
  with descender
3 Without descender
4 Simplest form
  conducive to
  handwriting

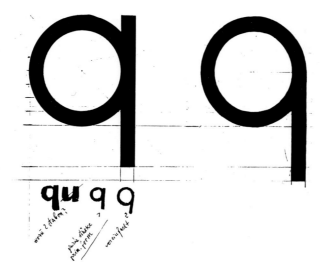

Bayer's sketch for the Universal q asks "Why two staffs?" Why repeat customs when they do not pertain to the present? The objective boundaries the child creates to avoid being engulfed by the mother are echoed in the objective "rules" created by Bayer to escape the subjective customs of the past.

*Translation of Bayer's notes*

Why two staffs?
1 Same weight, thickness, strength
2 Simplified

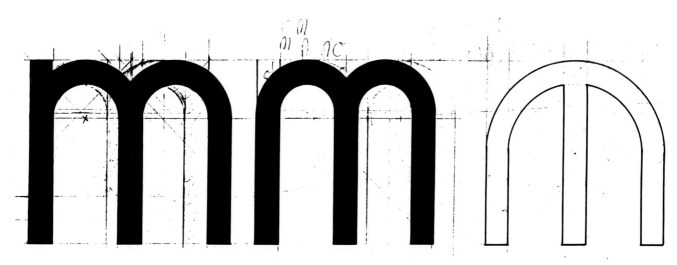

In contrast with the first *m* (1), whose thick and thin line is derived from the hand-held pen, and with the second *m* (2), which retains the ascender from handwriting, the structurally simplified, Universal *m* (in red) attempts to reflect "timeless" structural laws rather than human personality. Yet while the geometric reduction of the letterform could be interpreted as an objective and neutral method of design, it could also be interpreted as an active repudiation of the subjective and ornamental: qualities which Western culture has historically gendered as feminine.

*Translation of Bayer's notes*

1 Basic form
2 Same weight
3 Simplified
4 or
4a Simpler yet
5 or
5a-6 So it is easier to distinguish from the future N

## ▲■●: A Psychological Test

In 1923 Kandinsky circulated a questionnaire at the Bauhaus, asking respondents to fill in △, □, and ○ with the primary colors. He hoped to discover a universal correspondence between form and color, embodied in the equation ▲■●.

Kandinsky achieved a remarkable consensus with his questionnaire—in part, perhaps, because others at the school supported his theoretical ideal. The equation ▲■● inspired numerous projects at the Bauhaus in the early 20s, including a baby cradle by Peter Keler and a proposal for a wall mural by Herbert Bayer, although in later years some members of the Bauhaus dismissed Kandinsky's fascination with ▲■● as utopian aestheticism.

While few designers today would argue for the universal validity of ▲■●, the attempt to identify the grammar and elements of a perceptually based "language of vision" has informed modernist design education since the 1940s.

In 1990 we recirculated Kandinsky's "psychological test" to designers, educators, and critics. The replies range from straight-forward attempts to record an intuitive reaction, to statements which reject Kandinsky's original project as irrelevant to the aesthetic and social world of today. Reproduced here are a few of the responses.

### Kandinsky's questionnaire, 1923

Profession
Sex
Nationality

For purposes of investigation the wall-painting workshop requests solutions to the following problems:
1. Fill in these three forms with the colors yellow, red, and blue. The coloring is to fill the form entirely in each case.
2. If possible, provide an explanation for your choice of color.

### Frances Butler
Graphic designer and writer

Delving into the folk-lore of color and value, I assign colors to the three shapes in this way:

1. The Triangle = Yellow, because it is the most spiky shape, the least bulky, the lightest. This shape is the dancer, the sparkler.
2. The Circle = Red, because it is the punctum, the point, the heart of the matter, and hearts are red. The center, in Western culture, is the place of vitality, and vitality is bloody.
3. The Square = Blue, or true blue, the stability of the spatialized consciousness which we have developed since Euclid depends on the square, in a recessive color, as befits the shape that is the foundation, the support of all later shapes and ideas.

I do not so much use these shapes as I use the shapes between them, which are tension-filled and varied, whereas these shapes are quiet and stable, and therefore inadequate for my communication projects. All of my projects are designed to exploit the prevailing heteroglossia of "communication", today, with overlying fragments of texts from institutional and personal history forming a layered matrix of partial references and irony, with the only respite of clarity coming from an occasional effort to "bare the device" supporting the project narrative. In this approach I am following the notions of Rumelhart and McClelland described as parallel cognitive processing, in which all elements of the mind and body contribute continuously to a gross-grained best-fit search which makes up memory as it goes.

Memories have no locus, and lie within the connections, not in "places," or schemata. Therefore I think that your project to revive this early twentieth-century, or really, late nineteenth-century idea is an exercise in nostalgic futility. However, these longings are quite appropriate to our out-of-date culture in which, among other things, the old men in our government are trying to resume control over the bodies of young women.

   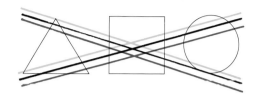   

**Dean Lubensky**
Graphic designer

These forms signify:

Empty, unradical, status quo design (Conrans!),

Academic design (they look so ''college''),

Institutionalized Design/Art,

Unapproachability.

Yellow, awkward color;
triangle, awkward shape.

Blue and square seem stable.

Red and circle seem dynamic.

**Rosemarie Bletter**
Historian of architecture and design

Today Kandinsky's association of color and form has purely historical significance. While the concern for a reductive universality in the 1920s is understandable as a response to the technological invasion of everyday experience, Kandinsky's specific reduction of forms to triangle, square, and circle and to the three primary colors, as well as his attempt to find a link between forms and colors, can be understood in terms of an older Western tradition in geometry and color studies. In a non-Western context these shapes and colors might have elicited different associations or might even have been considered meaningless.

Kandinsky's forms and colors do not have universal meaning or correspondence. If one had to identify a form that typifies the later twentieth century in Western culture, it would be the fractal, identified by Benoit Mandelbrot in 1977. Because of their open-endedness, their complexity in detail, fractals seem to address the paradox of order within apparently chaotic situations. Fractals are anything but reductive. Lyotard in *The Postmodern Condition* has classified fractals as Postmodern. Fractals are alluded to (at least their property of self-similarity) in the most recent work of architect Peter Eisenman. They are also widely applied in computer graphics for commericials. In a loose sense, self-similarity was a central organizational device in Gothic architecture.

Since fractals are vaguely reminiscent of the branching logic of computer programs, and because they were discovered by Mandelbrot while he worked at IBM, they will undoubtedly seem dated and associated with current computer culture in fifty years from now. Like Kandinsky's universal forms, they will become historical artefacts.

**Milton Glaser**
Graphic designer

**Brian Boyce**
Graphic designer and writer

—

**Gregory Ulmer**
Literary theorist

Pedagogical project: *The Square*

Experiment: Invention is square.
The instructions for the completion of this experiment are figurative. Produce a theory of design by means of the following generative sequence.

1. *Origami* (the art of folding paper).
What are the properties of the square that make it the most suitable shape for folding paper? It is both a rectangle and a rhombus; it has mirror symmetry both orthogonal and diagonal. Four corners with the same angle and four sides of the same length produce a vast undifferentiated middle.

2. The four fundamental bases of origami are: kite, fish, bird, frog. The corners or legs of Jacques Lacan's four fundamental discourse positions are: Master, Academic, Analyst, Hysteric. Take the following test:
A. Assign one of the discourse positions to one of the folding patterns.
B. If possible, provide an explanation for your choice.

3. Review the history of the square as an infantry formation. Note especially its function in the battle of Waterloo.

4. ''What does *receive* mean. With this question in the form what does X mean, it is not so much a question of meditating on the meaning of such and such an expression, as of remarking the FOLD of an immense difficulty: the relationship, so ancient, so traditional, so determinant, between the question of sense and the sensible and that of receptivity in general'' (Jacques Derrida).

**Mike Mills**
Graphic designer and writer

I have filled each form with all three colors, producing a murky brownish/black color.
    Rather than proving a universal and singular correspondence between color and form, my test demonstrates that each form can ''naturally'' contain any or all of the colors. The relationship between the shape and the color, or the sign and the signifier, is not a timeless constant but a culturally constructed, argued, and continually shifting ''agreement.'' The correspondence between the shapes and the colors (the meaning of language) is a political battle fought within the borders of a particular historical context.
    To validate a universal language of vision would naturalize the fabricated order men like Kandinsky create to gain mastery over their world.*

*See/hear, Queen Latifah, ''The Evil That Men Do.''

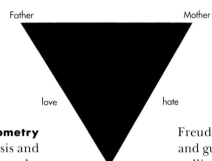

Father          Mother

love          hate

Child
in feminine
position

### 1  Psychoanalysis and geometry

The conjunction of psychoanalysis and geometry can be read either as the *psychoanalysis of geometry* or the *geometry of psychoanalysis*. The first phrasing, the *psycho-analysis of geometry*, suggests the possibility of finding essential sexual meanings for the basic shapes: ● might be equated with woman, ▲ with man, and ■ with the relation between them. Similarly, Kandinsky hoped to discover universal psychological meanings (perceptual rather than sexual) for these basic shapes. In contrast to such a search for universals, psychoanalysis insists that the meaning of a given sign is dependent on the personal and familial history of each person, a history which is in turn shaped by the culture in which she or he grew up.

### 2  The geometry of psychoanalysis

This phrase suggests instead that we look at the role of ▲, ■, and ● in the formation of psychoanalysis as a *particular* theory developed in the specific texts of a specific institution, rather than looking at the meaning of shapes "in general." This article explores the role of ▲, ■, and ● in the theories of Sigmund Freud (1856-1939) and Jacques Lacan (1901-1981).

### 3  The Oedipal ▲

According to Freud, the basic condition of human sexuality is described by the Oedipal ▲; it is a condition of *rivalry* (competition with one parent for the love of the other), *prohibition* (the impossibility of attaining the loved object), and *guilt* (the price of desiring the forbidden).

Freud would insist that rivalry, prohibition, and guilt are not "emotions" or "passions" welling up from within, but rather relationships inherent to every triangulation of three parties, whether in the family itself or in its repetitions throughout adult life: as the old proverb says, *"Two's company, three's a crowd."*

### 4  The ● of dual unity

According to many psychoanalysts, the Oedipus complex is preceded by the *pre-Oedipal* relationship of the mother and infant. This relationship is best described by ●, which functions in many cultures as a symbol of unity. The Ying-Yang symbol exemplifies the ideal of *dual unity*, of two interpenetrating halves coming together to form a perfect whole.

The child *in utero* is probably the closest that humans come to experiencing such unity. Childhood has been engineered in American culture in order to preserve that unity—by meeting the infant's needs as soon as possible, and by placing a very high value on the infant's care by its biological mother. And marriage is often understood as a return to this state: the couple is complete, self-enclosed and self-sufficient, bound together by the O of the wedding ring.

Psychoanalysis, however, insists that "dual unity," the pre-Oedipal ● of two, is more *imagined* from the point of view of Oedipal anxiety and jealousy than it is an actual state with duration and consistency. The pre-Oedipal ● shares the structure and impulse of the fairy tale: *"Once upon a time, I had Mommy all to myself..."*

Child
in masculine
position

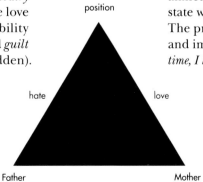

hate          love

Father          Mother

**5  Graphing Oedipus: Lacan's L schema**  Jacques Lacan, the most influential French follower of Freud, combined the teachings of psychoanalysis with those of structural linguistics, often through recourse to models offered by geometry. His graphs and formulas redraw traditional psychoanalytic concepts such as the Oedipal ▲ in terms of the role of language in human experience.

Lacan divided experience into three basic orders or registers: the Symbolic, the Imaginary, and the Real. The first two orders can be seen in Lacan's **L** *schema*, a diagrammatic structure developed early in his career.

The **o'- o** axis [ego/other] delineates the **Imaginary**. Like the concept of dual unity, the Imaginary implies a relation between two parties founded on a fantasy of oneness. The pre-Oedipal mother-child relationship can be mapped like this:

The **S - O** axis [subject/Other] delineates the **Symbolic**, which, like Freud's Oedipal ▲, involves the intervention of a third party into an idealized two-part relationship. The role of the father is mapped like this:

**Other** (with a capital **O**): this is the prohibiting voice of the father as it interrupts the unity of mother and child. Lacan also associates the Other with *language*, understood as the structure of symbolic and cultural relations which precedes and alienates each individual. Thus the paternal function occurs whenever *law* is in effect, whether represented by the father, day care, church, grandparents, or the mother herself.

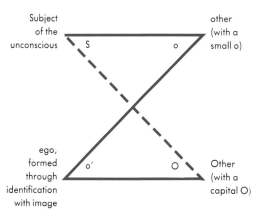

**other** (with a small **o**): The mother is the first other: the first object of identification, and an image of unity. Identification with this image is *narcissistic*, based on the perceived similarity of self and other in a mirroring relation ("mirror stage").

**ego:** The ego is the first sense of self, formed through identification with the mother. The ego identifies with the *shape* of the other: the ego, we could say, is shaped like a ●, the ● of dual unity. This sense of self is "imaginary" in two senses: it is based on identification with an image, and it is fictional, since the ego's apparent unity is always elsewhere, borrowed from the shape of the other.

**Subject:** for Lacan, "subject" always means "subject of the unconscious," in distinction from the ego, which is both conscious and fictional. The unconscious is formed when the father's "No" forces represssion of love for the now-forbidden mother. Lacan compares this process to *metaphor*, in which one word is substituted for another. Lacan's statement that *"The unconscious is structured like a language"* means that the unconscious is a system of linguistic substitutions triggered by paternal prohibition, the foundation of the first metaphor. For example, the phrase *"My love is a rose"* produces a symbolic substitute for the human love object. According to Lacan, the subject generates such substitutions because the original object of desire is forbidden or unattainable. Desire, and language more generally, functions as a chain of such exchanges.

**6 From ▲ and ● to ■** Like Freud's Oedipal ▲, Lacan's **L** schema presents the subject in relation to two "others": the Imaginary maternal object of idealization, and the Symbolic paternal agency of prohibition. The **L** schema, however, is a ■, not a ▲, since it graphs a division of the *subject* as well: the split between ego and unconscious.

Freud once wrote to a friend, "I am accustoming myself to regarding every sexual act as a process in which four individuals are involved" (364). For Lacan, the four points of the **L** schema represent not four people so much as four *positions*, four relationships to law, language, and image.

### 7 Graphing the Real: The R Schema

The **L** schema describes the relationship between the *Imaginary* (narcissistic identification with an image) and the *Symbolic* (the splitting of the subject by language as represented by a third agency). It does not, however, account for Lacan's third order, the **Real**. The **R** schema maps the inclusion of the Real within the **L** schema.

Lacan defines the Real as the chance encounters, the material events, different for each person, that configure his or her unique relation to the Imaginary and Symbolic orders of representation. The Real, which Lacan also defines as

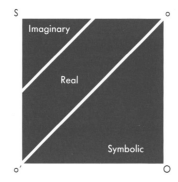

"the impossible," can be compared to Freud's theory of *trauma* as an event of excessive pleasure or pain around which symptoms, dreams, and screen memories collect.

The **R** schema fills out the open structure of the **L** schema into a full-fledged ■. The band of the Real separates and stabilizes the Imaginary and the Symbolic into two ▲'s. The **R** schema describes the structuring intrusion of the Real into both subject and graph—into subject *as* graph. The **R** schema depicts the self as an intersubjective field of representation, which crystallizes around accidental encounters with the Real.

### 8 Psychoanalysis and graphic design?

In 1898 Freud wrote to his friend, "I have an infamously low capability of visualizing spatial relationships, which made the study of geometry and all subjects derived from it impossible for me" (292). As usual, Freud transformed a personal weakness into a theoretical strength. Rather than use geometry to represent subjectivity as a unified shape or *Gestalt*, the psychoanalysis of Freud and Lacan employs geometric figures to map the psyche as an open field, in which different modalities of otherness interact with each other to construct the subject or "self."

Freud's Oedipal ▲ and Lacan's diagrams are *topological* rather than *topographical*, describing the self in terms of a structural logic rather than a geographic, spatial metaphor. This is why psychoanalysis is not a "psychology": it is a theory of the self not as a unified shape, a stable landscape, but as a system of relations. Psychoanalysis not only *graphs the subject* but *represents the subject as a kind of graph*, as a point or set of points in a series of relations extending beyond and within her or him. The psychoanalytic subject is an *intersubject*, never self-contained but always divided between competing (mis)identifications.

In thinking about a possible dialogue between psychoanalysis and graphic design, we would emphasize not the search for a set of coded shapes or symbols, but rather the theoretical concerns which the two disciplines share. ▲, ■, and ● can be understood both as **signs** (marks which acquire an arbitrary cultural significance) and as **structures** (patterns of opposition from which the significance of signs derives). The relationship between signs and structure is one of the central problems for linguistics and psychoanalysis; it is also a central theoretical issue for graphic design.

For letters and manuscripts from the formative years of psychoanalysis, see *The Complete Letters of Sigmund Freud and Wilhelm Fliess, 1887-1904*, ed. and trans. Jeffrey Masson (Cambridge: Harvard University Press, 1985).

For Lacan, see *Seminar, Book II, 1954-55: The Ego in Freud's Theory and in the Technique of Psychoanalysis*, ed. Jacques-Alain Miller and trans. Sylvana Tomaselli (New York: W. W. Norton, 1988) and Lacan, "The Mirror Stage," in *Ecrits: A Selection*, trans. Alan Sheridan (New York: W. W. Norton, 1977).

# Design in N-Dimensions

*Alan Wolf*

"The contrast between man's ideological capacity
to move at random through material and
metaphysical space and his physical limitations,
is the origin of all human tragedy."
Paul Klee, *Pedagogical Sketchbook*, 1925

In this "vector field" we attach a vector (an arrow) to each vertex on a 3-D grid. The length and angles of each arrow contain three additional pieces of information, so six dimensions of information are represented.

We perceive the physical universe as three-dimensional, that is, as containing at most three mutually perpendicular directions. This essay considers the possibility of life and design in an other than three-dimensional universe. Our discussion is limited to ordinary spatial dimensions. A four-dimensional "space-time" (the three spatial dimensions plus time) proves useful for formal mathematical work in Einstein's theory of relativity; the human experience, however, of moving through the time "direction" is quite different from the experience of moving through any of the space directions. For similar reasons this essay would reject the six-dimensional space represented at left. Recent cosmological theories suggest that for the first fraction of a second, the universe had more than three true spatial dimensions, most of which quickly collapsed.

Before we begin our tour of "other-dimensional" universes, we must first consider two different points of view (literally!) for the tour's narrator. Imagine that a one-dimensional (1-D) universe is embedded (placed) within our familiar 3-D universe, and suppose that this 1-D universe consists of the points along a simple curve. Our narrator might be a 3-D observer living in the 3-D universe, looking "down" on the 1-D universe, seeing all of its defining locations simultaneously, and noting its curvature. Alternatively, the narrator might be a 1-D observer living within the curve. Depending on whether the creature was one-eyed or two-eyed, its perception would be limited to the point ahead of it, the point behind it, or both. For the 1-D observer the curvature of its space would be neither visible nor relevant.

This difference of perspective is our first example of a *projection effect*. A simpler example is the loss of information that occurs when a 3-D object such as a baseball is rendered in a 2-D medium such as photography. Looking at a familiar 2-D image, we sense that we can undo the projection, completely recovering the 3-D object. But information truly has been lost in the projection—we could miss torn stitching in the hidden half of the baseball, or we could be fooled by a photograph of a photograph of a baseball. Our 3-D narrator can perceive surfaces, curves and points, but our 1-D narrator can only see the single point that results from projecting these objects down to his space.

Problems of projection confront us whenever we attempt to depict 3-D space on a 2-D sheet of paper. Various methods of projection have been devised, each with its own advantages and drawbacks. Shown above is a *perspective projection*, which imitates the perceptual distortion of parallel lines converging towards the horizon, and an *axonometric projection*, which preserves the parallel condition of lines.

An interesting aspect of projection is that an object or phenomenon that is "smooth" in its native dimension may project down to a pathological or "kinky" object of lower dimension. The branch of mathematics dealing with such effects is called "catastrophe theory." Here we show a simple 1-D curve sitting in 2-D. A series of arrows serves to guide us continuously along the curve. We then project the curve and the arrows down to a 1-D space. The sequence of projected arrows reveals that the curve has projected down to a line segment that folds back on itself twice. This looks quite sudden and discontinuous in the 1-D space, but it occurred gradually in the original 2-D space. Scientists and mathematicians hoped that catastrophe theory would help explain diverse discontinuous phenomena (e.g. nature, economics) as simpler processes in higher dimensions. [See Thom in references.]

**O** *dimensions*

We begin our tour with a zero-D space embedded in a 3-D space. A zero-D space could contain any number of isolated points, but as these elements cannot communicate among themselves, we may as well restrict the zero-D space to a single point. We note that a single-point universe is not large enough to have any two things in opposition, such as might motivate artistic expression. This is just as well, as a living entity occupying this universe would have nothing to do or observe, no space in which to create, and probably no thoughts (which likely require spatially differentiated biological functions).

**I** *dimension*

A 1-D universe would be consist of one or more *curves*. (A straight line is a special kind of curve.) Again we limit the space to a single curve rather than a collection of curves. In the 1-D universe a hair-like creature with length but no width or height could move forward and backward, but it could never pass a barrier or another creature.

Life is tedious in the 1-D universe. Debris (including excrement and corpses) breaks up the space into disconnected regions. Debris could be pushed around, but towards what end? The 1-D designer can only perceive dots to its right and left. Note that the 1-D designer would not necessarily perceive a dot as the insignificant object that we see: a dot would fill (or, for the two-eyed designer, half-fill) its visual "field." How the dot would actually appear would depend on the nature of this being's brain/mind.

The products of the 1-D designer would offer more variety to the 3-D viewer, who perceives the entire contents of the space simultaneously. Collections of points and/or line segments of different lengths, like those at left, might be interesting. Of course, no single 1-D designer could have constructed such a structure—it couldn't jump past the building materials. Other occupants of the space could be directed to push debris to assigned positions, or perhaps to move to those positions themselves. We are not limited to static designs: the motion of each creature might be choreographed.

1-D design may seem trivial, but we note that by varying the length and spacing of the line segments (as in Morse code), even a static pattern may contain as much information as a book or a musical composition.

time

space

morse code

It may or may not be possible for the 2-D designer to build versions of common 3-D tools. For example, gears seem essentially 2-D, until we remember that an axle must come in from a third direction to hold them in place! Gears can function in 2-D if they are restrained by surrounding parts, as in this two-dimensional clock.

We proceed to a 2-D universe embedded in a 3-D space. The universe is now a *surface* on which motion may occur in two perpendicular directions. (Note that the word "perpendicular" first acquires meaning in a 2-D universe.) The 2-D designer can now move around other creatures and materials. It is free to place materials in many diverse configurations without being confined by them. Lunch is a problem. A 2-D creature could not have a standard digestive tract, because the structure of mouth-to-stomach-to-intestines-to-anus would cut it in two. It might absorb food through its body by diffusion.

The 2-D designer with one or more eyes could move about (translate and rotate) in order to view its creations. Any object in its field of view could only appear as a single point or a line segment. Colors might be perceived in a 2-D universe, and with binocular vision, depth perception is possible.

As in the case of the 1-D universe embedded in the 3-D universe, the higher-dimensional creature can observe all locations in the lower-dimensional space simultaneously. While the 2-D observer can only see half of the outer perimeter of a circular object, the 3-D observer sees all of the perimeter, and all of the interior of the circle. Therefore the 3-D observer will be able to view the 2-D designer's internal body structure in addition to observing its handiwork.

Perhaps the 2-D universe possesses a star, a concentrated source of gravity. On earth, gravity reduces our up/down freedom somewhat (we can still jump, climb, and take the elevator), limiting our unconstrained motion to two directions. Similarly, in the 2-D space gravity would (mostly) confine motion to a single direction. Now you can't walk *around* building materials: you must climb *over* them. This is an annoyance, but gravity (and the friction it makes possible) is crucial for many kinds of construction.

If the 2-D universe had no gravity, structures would move freely throughout the space—once set into motion, objects tend to move forever at a constant speed. This could be confusing (Where did my house go?), so we postulate a universal viscosity that tends to bring objects to rest unless a sustained effort is exerted to move them.

Movement on a 2-D planet would be constrained by gravity in one of its directions, just as it is constrained on our 3-D planet. The designer of this 2-D building has divised spring-board contraptions for jumping from floor to floor. Each floor has length but no depth.

We move on to a 3-D universe embedded in a somewhat higher-dimensional space. We are familiar with the phenomena and perceptions of the 3-D occupants—among other developments, a proper digestive tract is possible. But what of the 4-D or 5-D observer looking down on our 3-D space? Our lower-dimensional examples extend directly to this case. Imagine a complex opaque 3-D object viewed by a 4-D observer, who can see *all* the surfaces, interior and exterior, of the object simultaneously. The 4-D observer would also be amused by the material and conceptual limitations of 3-D design, which lacks access to 4-D building technologies.

We now consider the converse of our original question. Instead of a higher-dimensional observer viewing a lower-dimensional space, we look for the perceptions of a lower-dimensional viewer looking at a projection from a higher-dimensional space. Consider an object built in a 4-D space and viewed from a 3-D one. Our senses couldn't detect the last dimension, but we could perceive the 3-D *projection* of the object into our space.

A lower-dimensional analogy is useful here—consider a 3-D cube pushed through a 2-D plane. The nature of the intersection varies greatly with the orientation of the cube relative to the plane and how far the cube has been pushed through. One possible sequence is a point of intersection, followed by a growing triangle, followed by a six-sided figure which evolves into a perfect hexagon, and then a reversal back to a single point of intersection.

Computers prove useful in visualizing objects projected down to spaces of lower dimension. A programmer can mathematically define a 4-D cube to a computer, as well as a method for rotating it around various axes in four dimensions. The computer can then project this object onto the 2-D computer screen by simply ignoring the last two dimensions. Note in the figures below that the rotating four-dimensional cube does not appear to be a solid object changing its orientation, but an object whose defining structure appears to change with time. It doesn't help much, but we can "understand" the complexity of this series of images as our inability to see novel kinds of interconnections. (Try explaining the axle to a 2-D designer.)

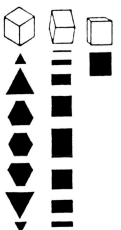

The intersection of the cube with the plane consists of closed figures, which would reveal the contents of the cube to a 3-D observer. A 2-D observer, however, would see only a portion of figure's perimeter. Instead of a plane, the 2-D designer would see a line segment, whose length might grow, shrink, grow, shrink, and then disappear.

## References

Edwin A. Abbott. *Flatland: A Romance of Many Dimensions by a Square*. London: Seeley & Co., 1884.

Dionys Burger. *Sphereland; A Fantasy About Curved Spaces and an Expanding Universe*. New York: Thomas Y. Crowell Company, 1965.

A. K. Dewdney. *The Planiverse: Computer Contact with a Two-Dimensional World*. New York: Poseidon, 1984.

Linda Dalrymple Henderson. *The Fourth Dimension and Non-Euclidian Geometry in Modern Art*. Princeton: Princeton University Press, 1983.

Rene Thom. *Structural Stability and Morphogenesis*. Reading, MA: W. A. Benjamin, 1975.

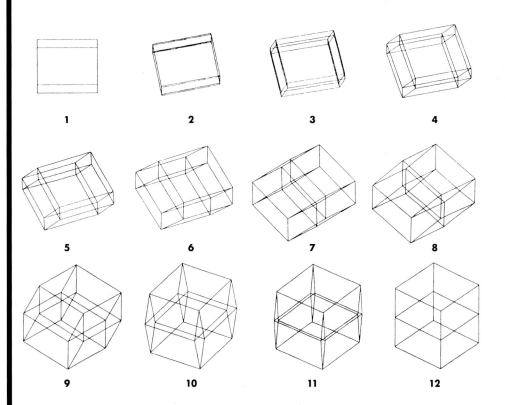

1    2    3    4

5    6    7    8

9    10    11    12

# Beyond ▲■●:

## Fractal Geometry

Alan Wolf

"Clouds are not spheres, mountains are not cones, coastlines are not circles... The number of distinct scales of length of natural patterns is for all practical purposes infinite. The existence of these patterns challenges us to study those forms that Euclid leaves aside as being 'formless,' to investigate the morphology of the 'amorphous'... Scientists will (I am sure) be surprised and delighted to find that not a few shapes they had to call *grainy, hydralike, in between, pimply, pocky, seaweedy, strange, tangled, tortuous, wiggly, wispy, wrinkled,* and the like, can henceforth be approached in rigorous and vigorous quantitative fashion."
**Benoit Mandelbrot**

Consider the apparently simple task of measuring the boundary of a fern. (We consider that the fern lies within a plane rather than having thickness, and thus is bounded by a curve.) Our measuring technique is to conform a piece of string to the perimeter of the fern as closely as possible. We then straighten the string and measure its length with a ruler. As we use thinner and more flexible string, we are able to conform to smaller features of the perimeter, and our value for its length gradually increases.

We expect our values to converge to the "correct" length, but instead they seem to be growing to infinity! We could continue until our "string" reproduces the locations of individual atoms on the perimeter, but our interest here is in features that can be perceived by the senses or measured with macroscopic devices, so we will retain the fiction that our measurement process could have continued forever. We conclude that either the *perimeter* of the leaf is infinitely long, or that the question of its length is not well posed.

Our measurement technique suggests reasonable variants of the question, such as, "How long is a fern's perimeter when features no smaller than *x* are measured?" Since our eyes and other tools always have limited resolution, another reasonable question is "How long is a fern's perimeter when it is measured by *x* tool?" On a computer screen, for example, the size limitation is usually a screen "pixel." Thus a computer representation of a fern (such as the one shown here) is bounded by a finite number of pixels.

Now consider a cloud. The interior of a cloud is a "solid" three-dimensional object: it has length, width, and height. In this sense the interior of a cloud is like the interior of a balloon. The balloon's surface is (in our idealized discussion) perfectly smooth, and is thus an ordinary two-dimensional surface with a finite area. The cloud's surface, however, is wrinkly from its grossest features down to its microscopic structure. The cloud's *surface area* tends to infinity as the resolution of measurement increases.

Mathematicians have quantified the wrinkliness of objects by modifying the standard definition of an object's dimension: in the new definition, points remain zero-dimensional, curves one-dimensional, and so on, but the *fractal dimension* of a cloud skin (from actual experimental measurements) has a value of about 2.3. Computer analysis of a photograph can provide such estimates. The value 2.3 suggests that a basically two-dimensional object is so wrinkled, it tends to act like a three-dimensional object.

This last remark is easily misunderstood: it is not the obviously correct statement that a crumpled two-dimensional piece of paper *occupies* a three-dimensional region of space (with some length, width, and height). What the statement *does* mean is that if the paper is wrinkled on all length scales, it tends to *densely fill* space like a solid three-dimensional object does: careful examination of the paper will not show that its "true" structure is two-dimensional, because the wrinkles never disappear at any level of scrutiny.

People instinctively recognize an object as *two-dimensional* when the points that cluster around any given point in the object surround it in *two* directions. We recognize an object as *three-dimensional* when each point is surrounded by points in *three* directions. Pick any point on the surface of a balloon. Look at other points on the surface near the first point. These points surround it in two directions that we might arbitrarily call right/left and back/forth. If we repeat the same procedure for a cloud, we find that

near any point, there are an infinite number of nearby points in these two directions, but *also* an infinite number located more or less above/below the given point, surrounding it less densely. In a piece of paper folded in an S-shape, there a *few* points above and below a given point, but not enough to add fractal structure, so the dimension of the object is exactly 2, not a little more than 2. But if the sheet is infinitely wrinkled, no matter how close to a point we look in the above/below direction, we find neighbors in the sheet.

Even when we add the infinite number of wiggles necessary for fractal structure, we may produce an object whose fractal dimension is only slightly larger than an integer. This is because an infinite number of wiggles might fill in a given direction only sparsely. Below, we see computer-generated fractal mountains, with a fractal dimension 2.1. Mountains with a higher or lower fractal dimension have a more or less bumpy look. The most naturalistic (earth-type) mountain ranges have a fractal dimension of 2.1.

Simple processes can generate fractals: no new physical laws need be invoked. These processes may be deterministic or random: that is, they may arise from either simplicity and order or from disorder. An example of a simple deterministic fractal is found in the kneading of bread dough. An amorphous mass of dough is alternately rolled out flat and then folded back over to its original shape. Each stretch-and-fold doubles the number of layers: a mere twenty folds produces $2^{20}$ or over one million layers.

Each layer of dough is two-dimensional; an infinite number of layers would add a fractional part to that. The fractal structure of dough can be represented with a *Cantor set*, generated by removing the middle third of a line segment, then removing the middle third of each remaining piece, and so on *ad infinitum*. The set consists of a finite number of line segments at each step, until the very last line, when it has a fractal dimension of 0.6309. The Sierpinski carpet shown above right is generated by a similar process.

**Sierpinski Carpet**
The area of the carpet vanishes, while the total perimeter of its holes is infinite.

Nature contains many hidden stretch-and-fold operations that build fractal structure. Since the discovery of fractal geometry in 1975, it is no longer possible to represent nature with a starter Lego set limited to such simple forms as ▲, ■, and ●. Now we know that we need an advanced set of building blocks which includes fractal forms of various types.

**References**

Benoit Mandelbrot. *The Fractal Geometry of Nature.* W. H. Freeman, 1977.

Michael Barnsley. *Fractals Everywhere.* Academic Press, 1988.

Designed by Ellen Lupton,
J. Abbott Miller and Mike Mills
Photography by Joanne Savio

The type used for the titling on the cover of
this book is 'Universal', a font designed by
Herbert Bayer in 1925 and redrawn in
Fontographer by Matthew Carter in 1991.
Bayer's font was never produced: prior to
Carter's reconstruction, the letters were
drawn by hand for each use.

The showing of Jan Tschichold's typeface
on page 40 was also redrawn by
Matthew Carter in Fontographer in 1991.

First published in Great Britain in 1993 by
Thames and Hudson Ltd, London

© 1993 The Cooper Union for the
Advancement of Science and Art,
New York

First published in the USA in 1991 to
accompany the exhibition, 'The ABCs of
▲ ■ ●: The Bauhaus and Design Theory
from Preschool to Post-Modernism'.

Printed and bound in Singapore
by C.S. Graphics